# ANCIENT GREEK TERRACOTTAS

BY

## C.E. VAFOPOULOU-RICHARDSON

ASHMOLEAN MUSEUM · OXFORD
1991

ASHMOLEAN MUSEUM PUBLICATIONS
*Archaeology, History and Classical Studies*

Treasures of the Ashmolean
Ancient Cyprus
Ancient Italy
The Arundel Marbles
Greek Vases
Scythian Treasures in Oxford

UNIFORM WITH THIS VOLUME:
Ancient Egypt
The Ancient Near East

Originally published in 1981 as *Greek Terracottas* (ISBN 0 9000 9080 4).
Reprinted in revised format, with the inclusion of colour plates, as
*Ancient Greek Terracottas*, 1991

**British Library Cataloguing in Publication Data**
Vafopoulou-Richardson, C.E.
    Ancient Greek terracottas. – 2nd ed. – (Ancient civilizations and art).
    1. Greece, Pottery, history
    I. Title II. Vafopoulou-Richardson, C. E. *Greek terracottas* III. Series
    738.8
    ISBN 1 85444 009 8

*Front cover illustration:* Fragmentary relief of a woman holding a goat (Pl. 21)
*Back cover illustration:* Black boy asleep (Pl. 35)

Designed by Andrew Ivett
Typeset in Ehrhardt by Meridian Phototypesetting Limited, Pangbourne, Berks
and printed in Singapore by Stamford Press Pte

# Preface

*Ancient Greek Terracottas* represents a selection from the Ashmolean's rich collection and includes some so far unpublished material. The author is grateful to Miss O. Godwin and Mr. N. Pollard for the photographs which were taken in the Museum's studio and to Miss Ceri Johnson who helped to redesign the book.

# Introduction

When Sir Arthur Evans gave his inaugural lecture on his appointment as Keeper of the Ashmolean Museum in 1884, he had occasion to remark that there were 'Hardly any terracottas, and what few we possess are by no means of the finest class'. However true this observation may have been in 1884, it is certainly untrue today, for the Ashmolean possesses a very fine collection which covers the whole of the Greek world, and includes representative examples from all the important centres of production, notably Attica, Boeotia, Taranto and Smyrna.

This happy state of affairs is due in large part to Sir Arthur Evans himself. Both during his Keepership and later, he was responsible for the acquisition by both gift and purchase of some of the most exquisite pieces the Museum possesses. These include the fragmentary plaque from Gela of a woman carrying a goat (No. 21), the antefix from Taranto of Silenus (No. 10), and the fragmentary relief which perhaps represents Eros and Psyche (No. 27).

Two former holders of the Chair of Classical Archaeology and Art in the University of Oxford, Sir John Beazley and Professor Bernard Ashmole, both enhanced the collection of terracottas with their generous donations. Others, too, have given or bequeathed important pieces. The most outstanding object in this category is the head of a youth found on the Esquiline at Rome (No. 39), bequeathed by Charles Edward Drury Fortnum (of Fortnum and Masons's) towards the end of the nineteenth century. Edward Perry Warren was a generous American benefactor, and Edmund Oldfield, Fellow and Librarian of Worcester College, a generous local one. Of the terracottas acquired by purchase, those bought from the collection of Lady Ottoline Morrell, the chatelaine of Garsington, friend and hostess to the Bloomsbury group, have a certain interest.

Many scholars nowadays still regard terracottas as secondary if not trivial pieces, which only show faint glimpses of the daily life and religious beliefs and practices of the ancient Greeks. This is an erroneous view, particularly with respect to terracottas of the Hellenistic period.

A great number of terracottas have been discovered in graves, sanctuaries, houses, and workshops or cisterns. It is difficult to explain their precise function when found in funerary contexts. Although some genre subjects have an explicit funerary connotation, with others it is more implicit. The coroplasts – makers of small figurines – fashioned the early examples by hand. When they became more sophisticated moulds were made, from which were produced many of the figurines we admire today. Certainly this was an economical and cheap method of producing children's toys. The use of terracotta figurines as toys and dolls is attested by ancient writers and confirmed by the number which have been found in children's graves. Figurines, however, often have a religious significance. This is more in evidence during the archaic and early classical periods. Many of the types described in this book have been found in votive deposits and appear to

3

have been made and bought for the sole purpose of being offered by their owner to a deity, e.g. Nos. 2–3, Nos. 25, 26; No. 28. Of the reliefs, some were made to decorate part of an incense burner or household altar *(arula),* which itself indicates some kind of private religious practice, or as revetments for architectural decoration (e.g. the Silenus antefix No. 10 or the head of a woman No. 36).

A purely secular art becomes more prominent during the late classical and early Hellenistic period, when the so-called Tanagra figurine appears. It is not clear what purpose this class of youthful, draped girls was designed to serve, but their presence in houses could suggest that some at least were intended simply as ornaments, reflecting the fashion and the way of life of the period. In particular this class can tell us a great deal about contemporary styles of dress and hair and types of jewellery.

Another class of classical and Hellenistic terracottas reflects the development of the theatre (e.g. Nos. 40, 42, 43), and these can be compared with other types of genre subject, such as the 'black boy asleep' (No. 35), and the grotesque women (Nos. 44, 45).

Moreover, during the Hellenistic period and particularly during its early phase, which no doubt is the most obscure period in all the long history of Greek sculpture, terracottas are our main evidence for style and development. Important centres of production such as Pergamon, Rhodes and Alexandria have left few if any original sculpture datable to this early phase. Athens is the same: Here too only the terracottas go some way to furnish a skeleton chronology and give an idea of what the style of larger works must have been.

Consequently these small scale works of art shed a remarkably varied light on many aspects of ancient Greek life and culture. This collection gives a good impression of this variety as well as possessing some pieces which are in themselves exceptionally fine.

**1 Seated goddess,** from Mesogeia, Attica. Attic, eighth century B.C.

This figure is probably an enthroned goddess whose throne (which was made separately) has not survived. Such seated figures are attested from the late eighth century, and it has been argued that they may have been inspired by seated cult figures. Our figure was modelled from a roll of clay tapered at the ends, and the legs were pinched to form feet. Hips and body are fairly cylindrical and the chest flattened, with two blobs of added clay to show the breasts. On the analogy of complete figures and the way in which her shoulders and upper arm are formed, we may assume that her arms (now missing) must have been extended along and above the arms of the throne. A long tapering neck is continuous with the head, which had a pinched ridge for a nose. Eyes are indicated by means of depressions. The hair falls straight on either side of her neck in simple tresses. An Attic geometric figure in the Metropolitan Museum, New York, of the same period and very similar to ours in both treatment and modelling, but actually seated on a throne, has been adduced as evidence for the existence of monumental sculpture in the eighth century. However a similar type comes from the Agora, and was found in a funerary context, suggesting that it was made for use in connection with funeral ritual rather than as a mere copy of a large statue.

1934.320. Bought. H. 18 cm. Red buff clay decorated with dark brown lustrous glaze. Solid.

Lit.: Higgins, *Terracottas,* 22, pl. 7A. For early seated figures: P. Kranz, *AM* lxxxiii (1972) 10–55, pls. 2–8. The New York statuette: V. Müller, *Metropolitan Museum Studies* v (1934–36) 162, fig. 6; 164, fig. 10. The Agora statuette: R. Young, *Hesperia,* Supplement ii (1939) 65, fig. 41.

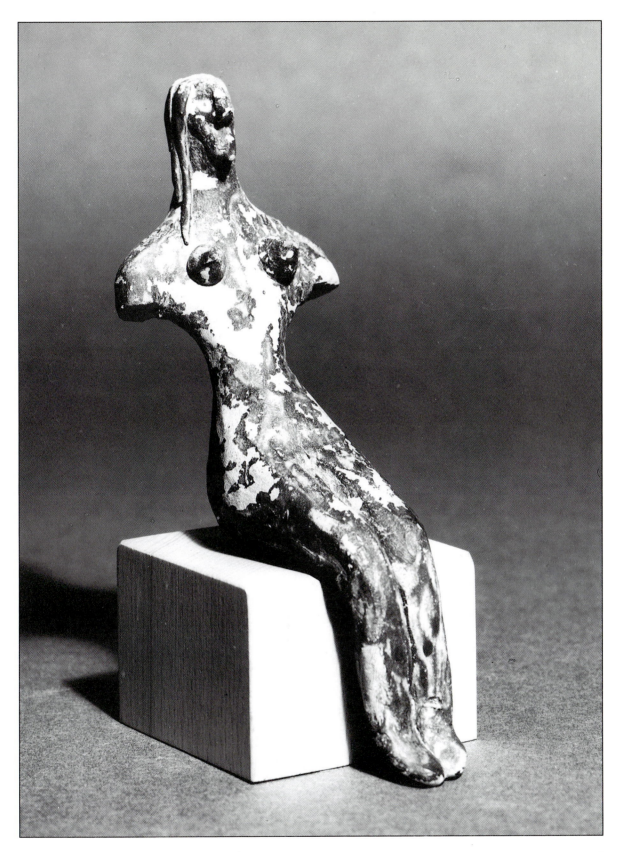

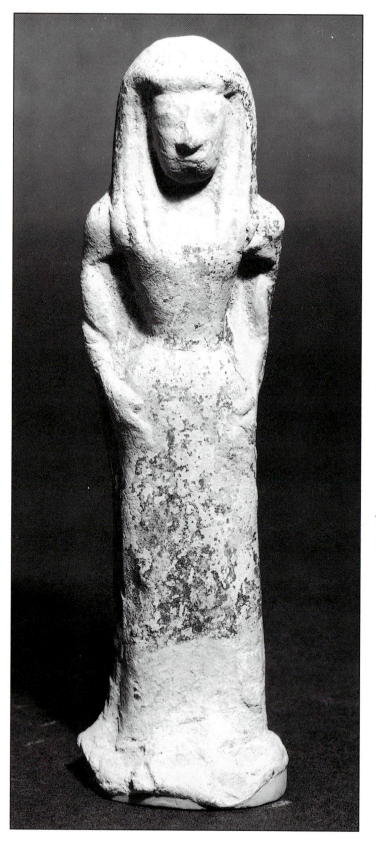

**2 Standing woman,** from Taranto, late seventh century B.C.

This Daedalic figure stands on an oval base with the legs together, but the feet are not shown. The Daedalic features are the frontality of the figurine and its two-dimensional treatment with a flat topped head, large eyes and prominent nose. The body is columnar and clad in a long tight-fitted *peplos* with a high belt, over which a veil or *epiblema* is worn, covering both shoulders and falling down the back. The arms hang flexed along the sides. The hair, arranged in Daedalic fashion, falls in thick tresses, divided horizontally on either side of the head. Above the forehead it may once have terminated in spiral curls (now rubbed away) as is the case with the Auxerre statuette in the Louvre. The face is rhomboid, with large staring eyes, protruding nose, thin lips, and a straight, low forehead. The figure reputedly comes from a very small deposit in the archaic stratum at the sanctuary of Persephone in Tarentum, a colony founded by Sparta *c.* 706 B.C. Similar types have also been found at Sparta and Gortyn in Crete.

1886.737. Presented by A. J. Evans. H. 18 cm. Pale buff clay with remains of black paint. Solid.
Lit.: A. J. Evans, *JHS* vii (1886) 25. J. Dörig, *AM* lxxvii (1962) 84, pl. 22; Higgins, *Terracottas* 54, pl. 22f.
The type is discussed in *BMCatalogue* 282, pl. 142, No. 1028. Spartan examples: R. M. Dawkins, *Artemis Orthia* (London, 1929) pl. 29, 3. Gortyn: G. Rizza and V. Santa Maria Scrinari, *Il santuario sull'Acropoli di Gortina* i (Rome, 1968) pls. 13, No. 72a, 23, No. 148b.

**3 Standing youth,** from Taranto, early sixth century B.C.

This naked youth of the so-called *kouros* type is shown standing on a high rectangular base, with his feet together. His arms hang closely along the sides of the body, with the palms resting flat against his thighs. Anatomical details are indicated by grooves, ridges and knobs on the surface: on his neck two deep grooves show the sterno-mastoids, whereas his clavicles are marked by ridges. The lower boundary of the thorax is indicated by a broad ridge with curved sides, which travels all the way round his chest like a breastplate. A small depression indicates the navel, and the nipples are well-defined. The lower boundary of the abdomen descends with straight sides to the genitals. The patterned muscles framing the knee cap, like two isosceles triangles, are also indicated in broad ridges bulging above and below. The proportions are abnormal, with a large head and short trunk. The facial features are well defined; large staring eyes set obliquely with upper and lower eyelids indicated, ears set low and modelled in different planes, mouth horizontal with thin lips, which do not meet at the corners, and a large protruding nose. The hair is arranged above the forehead in a series of spiral curls, and descends in beaded tresses, on either side of the neck to the chest. At the back it falls in an undefined mass.

The figure has been classified by Richter in the Orchomenos-Thera group, but surprisingly has few parallels among terracottas. Like No. 2, this example also comes from a votive deposit at the sanctuary of Persephone in Tarentum.

1886.744. Presented by A. J. Evans. H. 14.5 cm. Buff clay with some discoloration. Broken and mended at ankles. Solid.

Lit.: A. J. Evans, *JHS* vii (1886) 25, fig 3; Higgins, *Terracottas* pl. 22c; J. Boardman, *The Greeks Overseas* (London, 1980) 197, fig. 233; G. M. A. Richter, *Kouroi*, 3 edn. (London, 1970) 74, figs. 202–3.

For similar types found at Metapontum: V. Zanotti-Bianco, *JHS* lix (1939) 220, fig. 6 and P. Guzzo, *Archeologia Classica* xxiv (1972) 248-255.

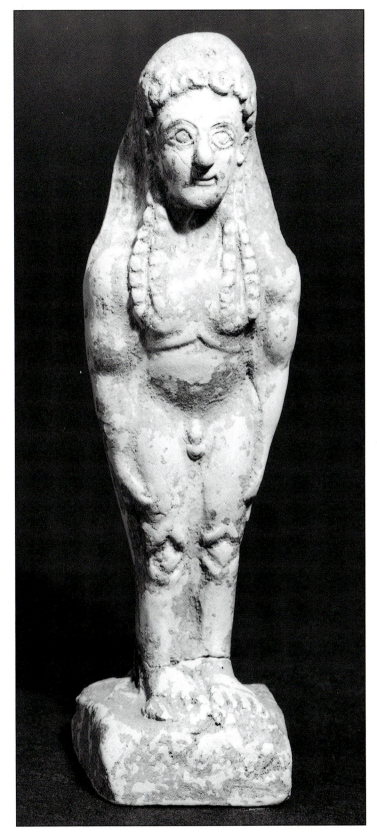

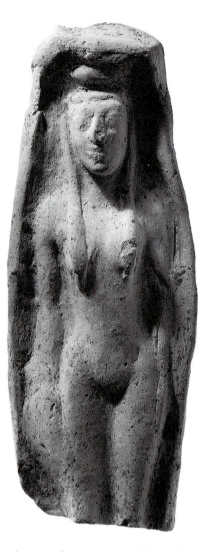

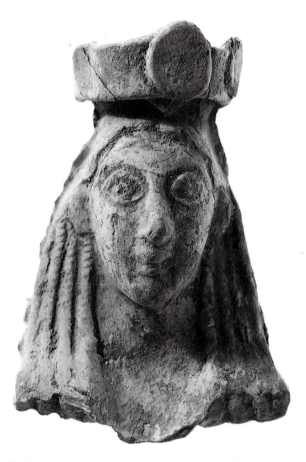

**4 Clay plaque of a naked goddess,** Crete, mid-seventh century B.C.

This moulded plaque represents a frontally facing nude woman standing with legs together and arms hanging alongside her body. She wears only a *polos* that was inserted before firing between the edge of the plaque and her head. The origin of the group to which this plaque belongs may be found in the Near Eastern Astarte plaques, on which the figure is wholly cast from a mould. The hair descends in long, plain tresses on either side of her neck. The features are Daedalic, with a thin face, large protruding eyes, and a long nose.

AE.403. Bought by A. J. Evans in 1899. H. 13.5 cm. W. 5 cm. Pinkish clay. Missing below knees.

Lit.: J. Boardman, *The Cretan Collection in Oxford* (Oxford, 1961) 115, pl. 39, No. 496; idem, *The Greeks Overseas*, (London, 1980) 76, fig. 74. For connections with the Syrian Astarte plaques: P. J. Riis, *Berytus* ix (1949) 69–90.

**5 Fragmentary female head,** From Taranto, *c.* 600–550 B.C.

The face is long and thin with a pointed chin and a full mouth. The hair is treated in four long spiral tresses and falls on each shoulder and behind the ears, which are shown flat against the hair on either side of the face. The eyes are large, with rimmed lids. The headgear is a *polos* decorated with rosettes. A head with a similar polos was found at Perachora and dates from the 590s B.C. Furthermore, our head shares many similarities in the treatment of the face and hair, with terracotta heads and bronze protomes from Sparta. Taranto was a Laconian colony, and therefore the influence of the motherland is not surprising.

1886.743 A. J. Evans gift. H. 6.7 cm, W. 4.6 cm. Pale orange clay. Solid, moulded in front with flat back.

Lit.: A. J. Evans, *JHS* vii (1886) 26, fig. 5; H. Jucker, *Antike Kunst*, Beiheft ix (1973) 56, pl. 14, 1. The Perachora example: H. Payne, *Perachora* i, (Oxford, 1940) 206–7, pl. 91, Nos. 37 and 42*b*. Sparta: R. J. H. Jenkins, *BSA* xxxiii (1932–33) pl. 8, 2 and Jucker, *op. cit.*, pl. 14, 2 and 3.

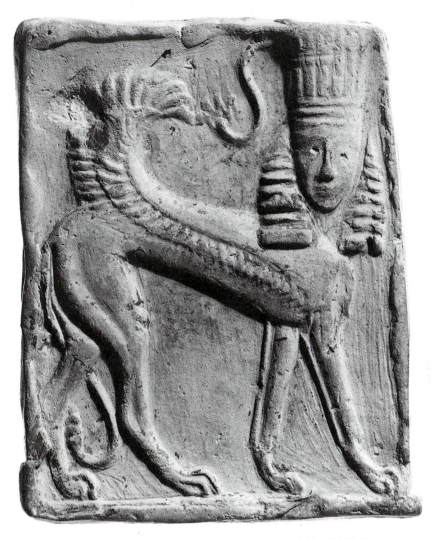

**6 Plaque of a sphinx,** from Lato, Crete, 630–600 B.C.

This plaque decorated with a sphinx belongs to a well-known series from Lato. The sphinx is shown striding towards the right, her body with its thin, sickle-shaped, wings shown in profile, whereas the head is shown frontally wearing a high *polos* decorated with horizontal and vertical stripes, and with a floral tendril flowing behind it. The hair is arranged in Daedalic fashion, with horizontal divisions on each side of the face, giving the impression of a wig. This type of hair style and tendril ornament, which also appears on a black figure alabastron from Knossos, seems to have its origins in Syria in the second millennium and was probably transmitted during the course of the eighth to seventh century B.C. through Syro-Phoenician art, on the one hand to Etruria, on the other to the Aegean. We find it in Crete on shields, on terracotta plaques, vases and *pithos* reliefs. Furthermore, two *pithos* fragments from Gonies Pediada show sphinxes with similar treatment

of wings (particularly the feathering) and hair which must be near to our plaque in date. The face of our sphinx is also Daedalic: triangular in shape with a long straight nose and two depressions for eyes, which were made after firing, perhaps in recent times.

G.488. Acquired by A. J. Evans. H. 9.6 cm. W. 7.5 cm. Red brown clay, with traces of black paint on the figure, border and background. Irregular with smoothed back.

Lit.: *Report* 1894, 4; F. Poulsen, *Der Orient*, (Berlin, 1912) 148, fig. 173; H. Payne, *Necrocorinthia* (Oxford, 1931) pl. 47.1 (detail of head); F. Matz, *Jdl* lxv–lxvi (1950–51) 99, fig. 5; J. Boardman, *The Cretan Collection in Oxford*, (Oxford, 1961) 116, No. 500, pl. 39; P. Amandry, *AM* lxxvii–lxxviii (1962–63) 63, No. 187, pl. 15. Hamburg Museum für Kunst und Gewerbe, Dädalische Kunst (Hamburg, 1970) pl. 46a.

Similar plaques from Praisos: P. Demargne, *BCH* liv (1930) 204–9, pl. 11; *Louvre* i, pl. 22, No. B177. Knossos alabastron: N. M. Verdelis, *BCH* lxxv (1951) 7, fig. 4. Gonies: D. Levi, *Hesperia* xiv (1945) 31, pl. 31, 1–2. Syrian antecedents: A. Dessenne, *Le Sphinx, étude iconographique* (Paris, 1957) 30, pl. 3, 12; Etruscan: Y. Huls, *Ivoires d'Etrurie* (Brussels, 1957) pl. 7, 2.

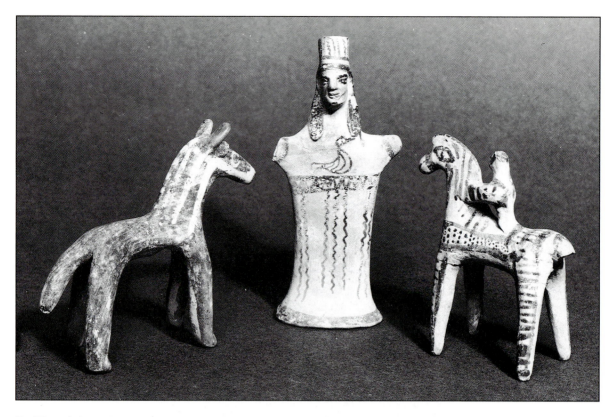

**7 Horse,** from Thebes, early sixth century B.C.

This horse must originally have had a rider, who is now missing. The decoration has largely disappeared but one can still see some white markings down the neck simulating the mane, and a circle for the eye. The ears and tail are roughly hand-modelled. Most of these figurines have been found in male tombs, which may suggest the worship of the dead man as a hero, as it is well known that horses played such a role in cults of the dead. However, horses in Boeotia also have a particular mythical meaning, and these may reflect Poseidon's equine form as a god of horses.

1893.110. Bought. H. 10.5 cm. Clay brown decorated with white paint. Solid, hand made.

Unpublished. Similar examples: P. N. Ure, *Aryballoi and Figurines from Rhitsona* (Cambridge, 1934); *BMCatalogue*, pl. 105, no. 787; Antikenmuseum, Staatliche Museen Preussischer Kulturbesitz, *Antiken aus Berliner Privatbesitz* (Berlin, 1975) No. 126.

**8 Standing woman,** from Thebes, *c.* 600–575 B.C.

She wears a *peplos* decorated with a broad band under her breasts and on the lower edge. A series of zig-zag lines down the front is a pottery pattern which here may suggest the folds. On her chest a duck is shown in outline. She has an oval face, with large outlined eyes, the chin thrust forward and a fleshy nose. The eyebrows are thickly painted black. Her hair is long and falls on each shoulder, behind the ears, in a solid mass. Her body is completely flat, flaring out at the base to make it stable. Her arms are short and triangular, pinched out of her sides, while her neck is long. She also wears a *polos*, which is decorated in linear patterns.

G.1. Bought. H. 15 cm. Clay yellow ochre with black glaze on hair, eyes and eyebrows, patterns in black glaze and applied red. Solid; head moulded, body hand made.

Unpublished. Similar examples: *Louvre* i, pl. 8, No. B64; F. R. Grace, *Archaic sculpture in Boeotia* (Cambridge, Mass., 1939) 32, figs. 23 and 25; *BMCatalogue*, pl. 102, No. 768.

**9 Horse and rider,** from Thebes, mid-sixth century B.C.

The rider, of whom only the upper part of the body is shown, appears to be bearded(?), with a thick neck. The horse's tail is broken. The rider seems to have placed both his hands on the horse's mane. Both rider and horse are decorated with stripes and dots. The horse's eye is outlined. This type of figurine has been found in a tomb at Rhitsona dated to the early sixth century B.C.

1893.112. Bought. H. 11.1 cm. Clay brown, decorated with black glaze. Solid, hand made.

Unpublished. Similar examples: Winter i, 7 figs. 2–3; P. N. Ure, *Aryballoi and Figurines from Rhitsona* (Cambridge, 1934), pls. 15–16; *BMCatalogue*, pl. 105, Nos. 785–6; J. Chesterman, *Classical Terracotta Figures* (London, 1974) 35, fig. 23; N. Breitenstein, *Catalogue of Terracottas* (Copenhagen, 1941), pl. 16, Nos. 151–2; A. Hundt and K. Peters, *Greifswalder Antiken* (Berlin, 1961) 106, No. 460, pl. 58; *Kestner Museum Jahresbericht* xx (1965–66) 300, No. 22.

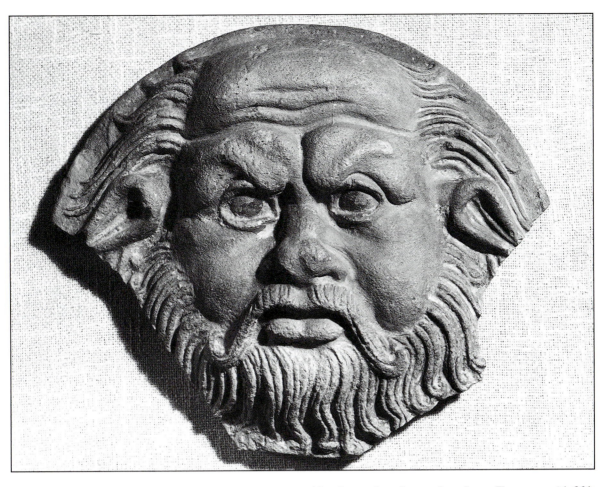

**10  Satyr head antefix,** from Taranto, mid-fifth century B.C.

This antefix represents the head of a bearded Silenus with a long moustache and receding hair. Three deep furrows cross his forehead, whilst his eyebrows are depicted as heavily arched, and give to the face a frowning expression. The eyes are shown wide open, with emphatic rims above and below. The nose is squat and fat. The hair, treated in short flame-like locks, is in contrast with the long wavy strands of the beard. The animal ears are set off in high relief. The closest parallels to this head are the mask-like Centaur heads from the Parthenon metopes and a terracotta Centaur in Basle. Two more variants of this type are also to be found in Basle. The facial characteristics are the same but the treatment of the beards and hair differs greatly.

G.27. A. J. Evans bequest. H. 23 cm. D. 29.5 cm. Clay cream. Remains of black on the eyelids and on the eyes and ears; the iris is painted red-purple and the hair yellow.

Lit.: C. Laviosa, *Archeologia classica* vi (1954) pl. 76,3.

Parthenon metopes: J. Boardman, *Greek Art* (London, 1973), 120, fig. 122. Basle centaur: H. Herdejürgen, *Götter, Menschen und Dämonen* (Basle, 1978) 41, No. A32. Similar examples: *ibid.*, 92, Nos. C9–10; G. Cultrera, *Bollettino d'arte* vii (1927) 326, fig. 39.

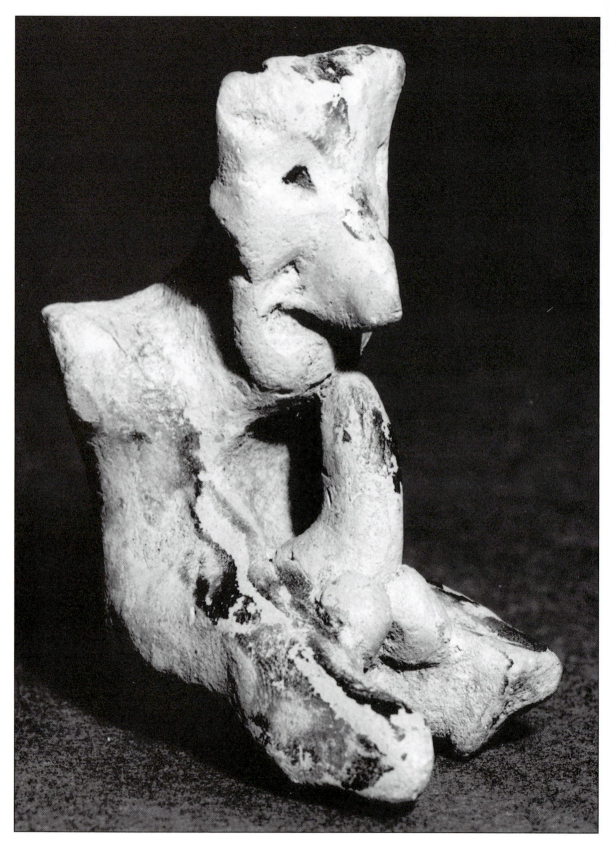

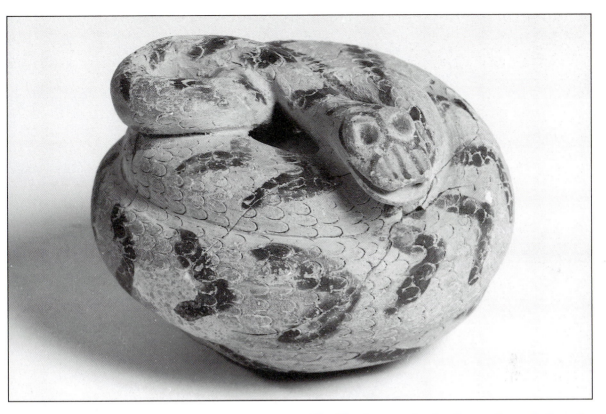

**12 Plastic vase in the form of a coiled snake,** probably Boeotian, 600 B.C.

The vase body is formed by the coiled body of the snake, whose last loop forms its mouth. On its body the scales are impressed. The eyes are formed by two hollow depressions and must have been inlaid with some substance which is now missing. They are surrounded with circles of brown paint, while parallel strokes decorate the upper opening of the mouth. The vase bears on its upper coil a Greek inscription, which was scratched after firing, 'Grypes gave (me) to Hermaia', in the Boeotian alphabet. The letter forms suggest a Boeotian origin of the early sixth century B.C. There are two similar complete plastic vases in the form of snakes, one in Toronto, the other in the Louvre. The earliest known example, dated to the middle of the seventh century B.C., comes from Perachora and is of Protocorinthian fabric, unfortunately fragmentary. Such snakes may have inspired Boeotian imitations, which seem to draw their inspiration from the Ionian East as well as from Corinth.

1956.314. Purchased. H. 4.5 cm D. 7.6 cm. Clay pink with buff surface Some brown paint in the form of chevrons remains.

Lit.: *Report* 1956, 22, pl. *5b; Archaeological Reports* 1961, 55–6, fig. 4; I. Raubitschek, *Hesperia* xxxv (1966) 159, pl. 51*b.*

The Toronto example: D. M. Robinson and C. G. Harcum, *Catalogue of the Greek Vases in the Royal Ontario Museum of Archaeology* (Toronto, 1930) 40–41, pl. 11, No. C219. Louvre: *CVA* xvii, pl. 17.1. Perachora: H. Payne, *Perachora* i (Oxford, 1940) 239, No. 220, pl. 106.

**11 Ithyphallic male figure,** from Sparta, seventh to sixth century B.C.

This example comes from the sanctuary of Artemis Orthia at Sparta. Dawkins, the excavator, considered such figurines to be extremely common between 700 to 500 B.C. On stylistic grounds our figure should perhaps be placed somewhere at the end of the seventh or beginning of the sixth century B.C. He is shown seated with both legs stretched in front. An erect phallus reaches his chin. The arms are missing. His head is rather big and is rhomboid in shape, seen in full face, with a very marked projecting nose and a full, square chin perhaps meant to indicate a beard. The mouth is omitted, while the sides of the face are flattened, and the eyes are indicated by small depressions. Similar hand-made grotesque male figures were also found in Corinth.

1923.165a. From the British School excavations. H. 5.8 cm. Hand made, no vent. Clay brownish-orange. Some traces of black paint remain.

Unpublished. Similar, but less explicit examples: R. M. Dawkins, *Artemis Orthia* (London, 1929) 15, pl. 40, 9–10.

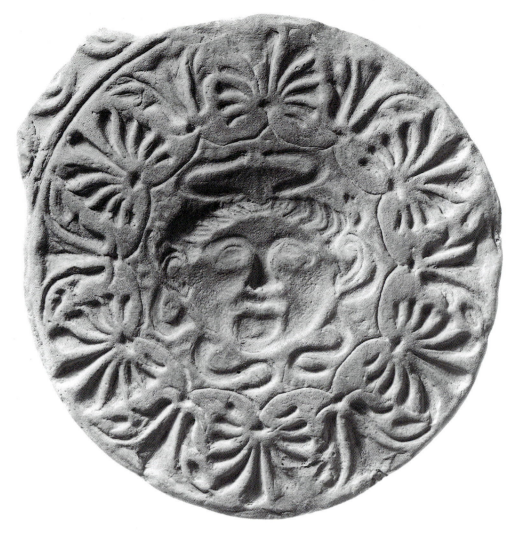

**13 Disc mould,** from Taranto, *c.* 300 B.C.

This disc-like mould has in its centre the head of a Gorgon, surrounded by a border of alternating lotus flowers and palmettes. The hair of the Gorgon appears to be parted and treated in separate strands, which in their turn are brushed back behind the ears, which stick out on either side of the face. Snakes radiate from above her forehead and behind her ears. Her face is fat and her tongue is pulled out, hanging over her chin. Heavy arched eyebrows frame her large eyes, whose details, however, are abraded. On the left side of the disc, part of a projecting handle remains. Wuilleumier, who has studied these disc-like objects in his extensive work on Taranto, divides them into two categories: one group is of small dimensions and always bears an inscription in relief, the second, which is much larger and often has a handle, bears no inscription.

1886.679. D. 20.5 cm. Clay pale orange. Handle broken off.

Lit.: A. J. Evans, *JHS* vii (1886) 44; P. Wuilleumier *Revue archéologique* 1932 vol. 35–36, 58, 2.

Similar examples: *ibid.* pl. 2, 4; P. Wuilleumier, *Tarente, Des origines à la conquête romaine* (Paris, 1939) 543–548.

**14 Impression from disc mould** from Taranto, *c.* 300 B.C.

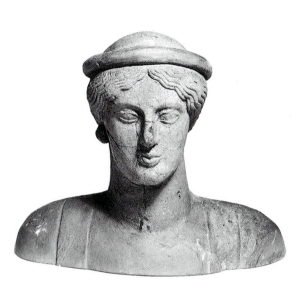

**15   Female *protome*,** from Locri, mid-fifth century B.C.

The head is set straight on the neck, and recalls in treatment the previous head. The face is thin and oval in shape, with straight nose and full fleshy lips. The eyes have both upper and lower eyelids clearly modelled underneath the eyebrows. The triangular forehead is framed by the wavy lines of the hair style, which is parted in the middle and softly crinkled on either side of the face. The woman wears a diadem, and globular earrings in her ears (left one is missing). The *himation* covers both shoulders, and its edges, treated in a large flat fold, hang straight on either side of the neck.

1930.268. Formerly in the collection of Lady Ottoline Morrell. H. 13.1 cm. W. 17.6 cm. Clay red-brown. Badly cracked and mended (right shoulder restored).
Lit.: *Report* 1930, 11.

**16   Female head,** from Locri, mid-fifth century B.C.

This head is set straight on the neck, and reproduces a well-known type which occurs in many variants among the Locri-Medma terracottas. The face is thin and long, with a straight nose and a small full mouth with its corners delicately modelled. The chin, small and round, accentuates the oval of the face. The eyes, with their upper and lower eyelids indicated and softly modelled, show the characteristics of the Severe Style underneath the neatly arched eyebrows. The hair parted down the middle is gently waved on either side of the face, but cut off short at the back. The treatment of the hair and facial characteristics recalls some of the marble heads from the metopes of the Temple E at Selinus.

1930.274. Formerly in the collection of Lady Ottoline Morrell. H. 12.5 cm. Clay deep red and gritty. Slightly restored at the base of the neck, with some minor cracks on the surface.
Lit.: *Report*, 1930, 11.
The Locri-Medma terracottas: P. Orsi, *Notizie degli Scavi* 1913, Supplement, 108–13, figs. 124–47; R. Holloway, *Greek Sculpture of Sicily and Magna Graecia* (Louvain, 1975) 8, figs. 59–60.

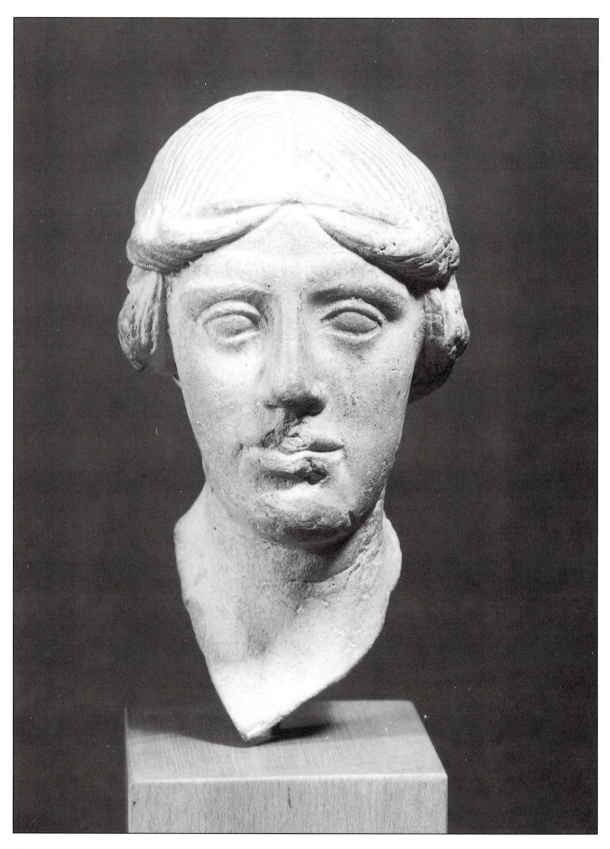

16

**17  Female head,** from Taranto, *c.* 460–450 B.C.

This head is a fine copy of a well-known sculptural type, whose original most probably was a bronze. There are several marble replicas and two in terracotta: this one, and a smaller (8.5 cm. high) head in Budapest. The face is a narrow oval with sharply outlined features. The eyes underneath the heavy arch of the eyebrows give to the face a slightly distant expression. The eyelids, with a clearly defined tearduct, are softly modelled and gently frame the eyeball. The low triangular forehead, the straight nose, the full lips and the forceful chin all flow subtly into one another. Unfortunately the back of our head is missing, but the hair most probably was rolled into a massive ball-like knot at the nape, similar to that seen on the marble versions of the type. The ribbon on these marble heads does not appear on the front, but is visible on the sides, at least on the better copies, as in New York, and in the Ny Carlsberg Glyptotek in Copenhagen (a cast of the Copenhagen example can be seen in the Ashmolean Cast Gallery). The rendering of the hair is very fine and it is treated in close incised strands which recall metal work (*e.g.* a bronze head from the Athenian Acropolis). Fortunately we know the type of statue to which these heads can be assigned, thanks to the identification by L. Mariani, who saw a complete statue in the public garden at Candia in Crete. The Ashmolean Museum also possesses a headless copy of the type, but unfortunately badly preserved; the treatment of its drapery also echoes a bronze prototype, which may have been created *c.* 460 B.C. in the Peloponese.

G.29. Bought in Taranto. H. 12 cm. Clay pale-cream. Upper lip damaged, back of head missing.

Lit.: Ashmolean Museum, *Summary Guide to the Department of Antiquities* (Oxford, 1951) pl. 37*b*; W. Trillmich, *Madrider Mitteilungen* xvi (1975) 231, n. 91 (with earlier bibliography), pl. 27 *a–b;*

The Budapest piece: G. Schneider-Hermann *BABesch* xlvii (1971) 140, fig. 3. New York: G. M. A. Richter, *Bulletin of the Metropolitan Museum of Art* xxv–xxvi (1930–31) 95–96. Acropolis head: M. Robertson, *A History of Greek Art* (Cambridge, 1975) pl. 52*c.* Candia: S. Mariani, *Bullettino Communale* xxiv–xxv (1896–97) pl. 12.

**18  Standing man,** Rhodian *c.* 540–520 B.C.

This figure stands on a rectangular base with his left leg forward. The arms hang along the sides. He wears a *chiton* with short sleeves, and a *himation* arranged diagonally from his left shoulder to beneath the right armpit. The right edge falls in a series of zig-zags. The hair is smooth on the crown but falls in long tresses on either side of the neck down to the chest. At the back it is arranged in a solid mass, divided into horizontal waves. The face is plump and the features well defined: long narrow eyes, heavy jaw and small smiling mouth. The figurine has features in common with a group of late archaic figurines from the East Greek islands. The type used to be considered female, but a comparison with contemporary Samian free-standing sculpture shows it to be male. Indeed, a large-scale sculptural prototype may even have inspired the series. The type is widespread, and one has recently been found on Thasos.

G.9. H. 24.3 cm. Clay orange with remains of black paint. Hollow, no vent.

Unpublished. The type is discussed by E. Buschor, *Altsamische Standbilder* i-iii (Berlin, 1934) 46, pls. 163–164 and in the *BMCatalogue,* 71 pl. 30 No. 151. The Thasos example: N. Weill, *Revue Archéologique* 1976, 219, figs. 5–6.

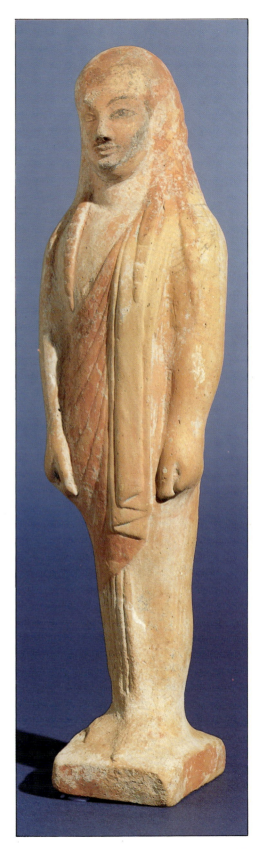

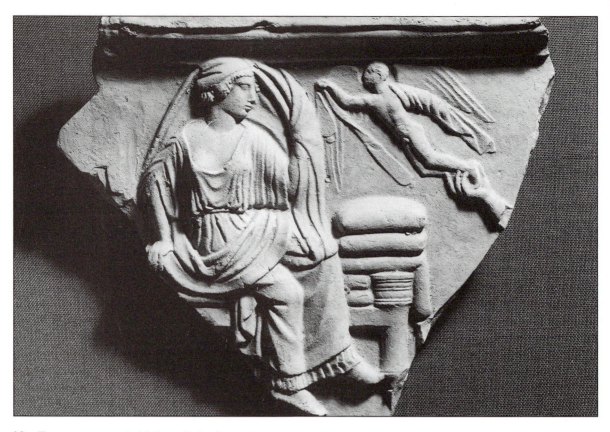

## 19 Fragmentary bridal relief, from Taranto, *c.* 425–400 B.C.

This relief fragment once formed part of an *arula* (incense burner) as the careful moulding of its cornice indicates. Such mould-made reliefs were particularly popular in Taranto and its surrounding area for the decoration of *arulae*, which may have been used in houses, temples or, as P. Wuilleumier suggested, in *necropoleis*. A complete version of the scene is preserved on a plaque from Taranto, thus enabling us to understand the significance of its iconography. On our relief a young girl is shown seated on the edge of a bed. She wears a long-sleeved *chiton* tied with a belt round her waist, and thus forming a series of loop-like folds over it. This treatment recalls in general terms that of the figure of Selene on the Parthenon East pediment. Over the *chiton* she wears a *himation* in the form of a veil and with her left hand she seems to pull it so as to cover her face. This gesture is only understood when one looks at the Taranto relief mentioned above. There on the right stands a female figure draped in a similar fashion to our seated girl, and her right arm extended holds the feet of a small flying Eros, who carries a *taenia* (ribbon) to the bride. This figure is identified as Aphrodite, who has surprised the bride by appearing before her eyes. Between her and the bed stands a *hydria* with a *cista* (box) placed on top, both requisites for a wedding in classical Greece. Therefore the entrance of the goddess should be seen as an epiphany visible only to the bride, who tries to hide herself, whereas the little servant girl who sits at the foot of the bed on a low stool is oblivious to what happens above. Both these figures are missing from our relief, apart from the right hand of the goddess, on which Eros' feet rest. The bride's hair escaping from underneath the headdress *(kekryphalos)* is treated in loose curls, the almond-shaped eye appears half-shut, and the full mouth gives her a pensive expression. The facial characteristics and hair treatment point to a date round the middle of the fifth century B.C., but the drapery is certainly more advanced and indicates the last quarter of the fifth century B.C.

A similar relief exists in Brindisi, and a fragmentary relief of the same type has been found at Heraclea, a Tarantine colony. Both dimensions and details correspond to those of the Taranto plaque, which suggests that the mould may have been imported from the mother-city.

1886.681. A. J. Evans gift. H. 19 cm. W. 12 cm. Clay cream.
Lit.: A. J. Evans, *JHS* vii (1886) 33; E. Jastrow, *Opuscula Archaeologica* ii (1941) pls. 2–3.
Taranto: P. Wuilleumier, *Tarente, Des Origines à la conquête romaine* (Paris, 1939) 433. The Brindisi plaque: B. Sciarra, *Musei d'Italia, Brindisi* (Bologna, 1976) 39, 261; Heraclea: G. Lo Porto *Bollettino d'Arte* xlvi (1961) 138–139, fig 12.

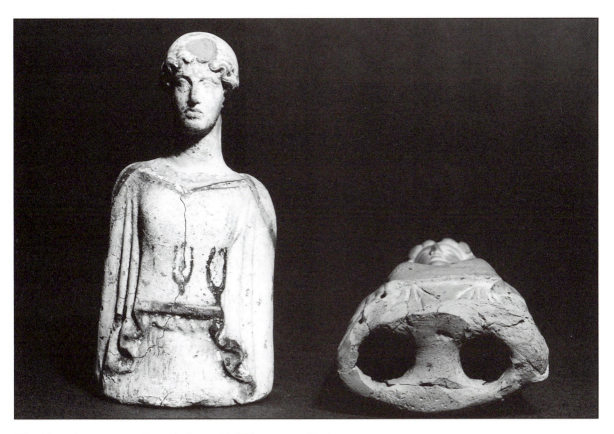

**20　Female *protome*,** from Attica, mid-fifth century B.C.

This *protome* shows a female figure clad in a Doric *peplos* with fine crinkly folds, a *kolpos* (the overfall of material pulled over the belt), and an *apoptygma* (the bib-like material which falls from the shoulders to the hips) whose upper and lower edges have a purple border. Her arms hang along the sides of the body. Her hair, parted in the middle, is treated in deep waves round the face, and is held in a *sakkos* (a headdress whose point is broken off) at the back. This seems to be a reduced version of a well known standing type, dated to about 450–440 B.C., which is also attested in other centres such as Boeotia, Cyrenaica and Sicily. The class is discussed by Poulsen, who refers to them as dolls, but Higgins disputes this point on the grounds that this type of figurine was never pierced for the insertion of movable limbs. Furthermore, as the fuller versions indicate a solid mass of drapery for the lower region,

this type can hardly be intended as a doll. He suggests that possibly the lower part was made of some perishable material, such as wood or cloth, which was inserted in the holes underneath. But these holes are also very suitable for fingers, so that the figure can be used as a 'glove' puppet. Similar examples have also been found in Delos in a child's grave, as well as in a grave in the Kerameikos cemetery at Athens.

1929.461. Bought in Athens and presented by J. D. Beazley. H. 14 cm. Base 4.0 × 7.0 cm with two holes 2 cm. in diameter. Buff clay with white slip almost complete. Back below shoulders unworked.

Lit.: *Report* 1929, 11; T. B. L. Webster, *Greek Terracottas* (London, 1950) 18; Ashmolean Museum, *Select Exhibition of Sir John and Lady Beazley's Gifts* (Oxford, 1967) 161, pl. 78, No. 610; V. H. Poulsen, *Der Strenge Stil* (Copenhagen, 1937) 51. 6, 7.

The standing type is discussed: *BMCatalogue* 217, Nos. 813–814; 378, No. 1411, and similar type, *Louvre* i, 83, Nos. C10, C11. The Delos example: K.A. Romaiou, *Arch Delt* xii (1929) 199, fig. 7. Kerameikos: K. Kübler *Archäologischer Anzeiger*, 1935, 273–74, fig. 6.

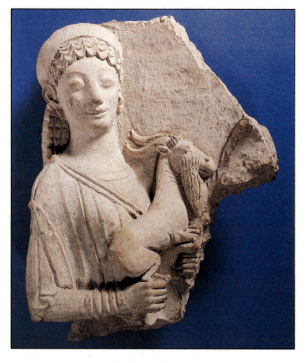

has a low forehead, the eyes are almond shaped – the lower eyelid shown in slight relief, with the upper one hooded – and the nose is straight. The full lips, with the upper one slightly protruding, are sharply finished at the corners, thus giving her the smile typical of the archaic period. All these details point to a date towards the very end of the sixth century B.C.

G.8. Acquired by A. J. Evans. H. 28.8 cm. W. 22.9 cm. Clay pale cream.

Lit.: *Report* 1889, 5; Winter iii, 108, fig. 8; P. Gardner, *Mélanges Perrot* (1903) 121–24; R. W. Hamilton, *Treasures of the Ashmolean Museum* (Oxford, 1970) fig. 20; *Enciclopedia dell'arte antica* iii (1960) 802, fig. 995; R. Holloway, *Greek Sculpture of Sicily and Magna Graecia* (Louvain, 1975) 14, fig. 15.

For similar jewellery: C. Carducci, *Ori e argenti dell'Italia antica* (Milan, 1962) pl. 22; R. Kekulé, *Terracotten von Sicilien* (Berlin/Stuttgart, 1884) 45, 96; Locrian Pinakes: H. Prückner, *Die Lokrischen Tonreliefs* (Mainz, 1968) pl. 7. 1, 6.

## 21  Fragmentary relief of a woman holding a goat, from Gela, Sicily, 510–500 B.C.

This relief represents the upper part of a female figure which Gardner identified as Aphrodite, but which Holloway prefers to interpret as Artemis. She could, however, simply be a votary carrying a small goat as an offering to some deity. Similar votaries occur on Locrian pinakes.

The woman is shown wearing a plain *stephane* (diadem) on her head, above the scalloped waves of hair which frame her face in a manner similar to that of the Athena from the East pediment of the Aphaea temple on Aegina, for it is combed behind the ears and falls in a similar way down the back. Her ears, which are rendered very realistically and are pierced, are adorned with spiral-shell earrings. Round the wrist of her right hand is a coiled bracelet, similar to the ones made by Greek goldsmiths of the period.

She is dressed in a *chiton* with full sleeves, which hang in a series of zig-zag folds to the right elbow, and a mantle which is worn obliquely and fastened on the right shoulder and down the arm, with two large buttons. This fashion is very reminiscent of some of the archaic *korai* from the Athenian Acropolis and the Caryatids on the Siphnian Treasury at Delphi. But here the folds are treated in a more summary manner and appear to be rather large and flat, with very little modelling. On the other hand, the figure itself is treated in very high relief, with the body hollowed against the background, and is comparable to a relief which seems to have been used for decoration in a shrine. The face

## 22  Seated goddess, probably from Selinus, early fifth century B.C.

This fragment shows the upper part of a seated goddess, a well known type among the Locrian terracottas. The female figurine is shown seated on a throne, with a tall back and wings elaborately decorated with horizontal palmettes. She is wearing a *chiton* with fine crinkly folds, framed by a *himation* which covers both shoulders and arms, hanging along the side of the breasts in a series of flat zig-zag folds. Her hands appear to have been resting on her lap, where once a dove stood. Here only its head can be seen. Her hair is parted down the middle and arranged in a bunch of fine waves on either side of the face, and crowned by a plain circlet with round ornaments. She also wears a pair of globular earrings. The lips are thin, with a faint smile visible. The eyes are almond shaped and have the upper and lower eyelids clearly defined. The forehead is low and triangular in shape and descends into a full straight nose. A certain fleshiness of the face, characteristic of South Italian work, is apparent. All these features point to a date in the early fifth century B.C.

1960.1304. Sir Leonard Woolley bequest. H. 20.5 cm. W. 20 cm. Clay cream.

Lit.: *Report* 1960, 18, pl. 4a.

For complete examples: G. Foti, *Il Museo Nazionale di Reggio Calabria* (Naples, 1972) pl. 17. Similar heads: *ibid.*, figs. 34 and 37; R. Holloway, *op. cit.* (under No. 21 above) pls. 68, fig. 43 and 69, fig 47.

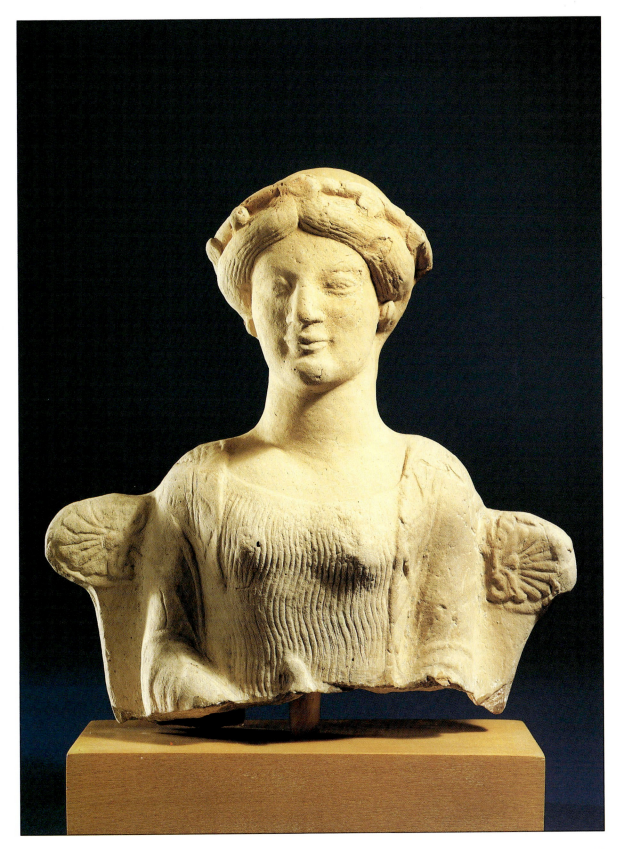

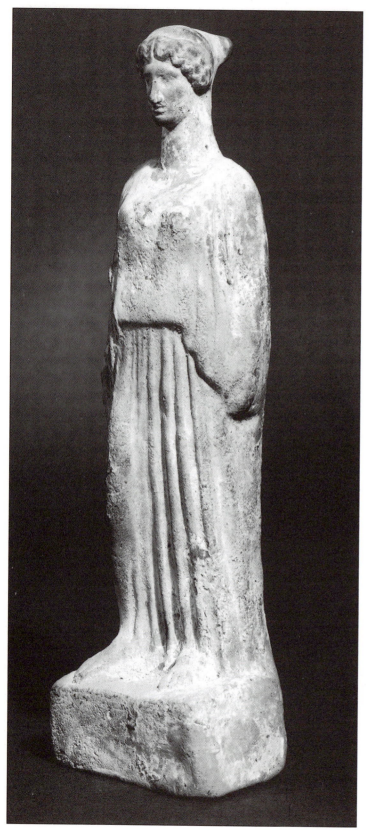

## 23 Standing woman, from Boeotia, mid-fifth century B.C.

The woman stands on a high rectangular base, with the right leg carrying the weight and the left slightly flexed. Her arms hang by the side of her body.

She is clad in a plain *peplos* with *apoptygma* (see No. 20), which is open down the right side, and on her head wears a high *polos*, raised at the rear, and terminating in three projections. This *polos*, which appears to be peculiar to Boeotia at this period, may be considered to be a transitional form between the sixth century high *polos* and the low *polos* of later periods. It has also been suggested that it may have some local cult significance. Her hair, parted and waved, falls down her back. Her features are well defined, a long straight nose, full mouth, small round chin, eyes with upper and lower eyelids indicated. A very similar type has been found in a grave at Halae in a context dated between *c.* 450 and *c.* 420 B.C.

1926.552. Bought. H. 30 cm. Clay tan with remains of white slip and traces of red paint. Back not moulded, large rectangular vent.

Lit.: V. H. Poulsen, *Der Strenge Stil* (Copenhagen, 1937) 74; Winter, i, 62, 4.

The *polos* is discussed by: V. Müller, *Der Polos die griechische Götterkrone* (Berlin, 1915) 41, No. 5; P. N. Ure, *Aryballoi and figurines from Rhitsona in Boeotia*, 58, fig. 8, No. 138.9; H. Goldman, *Hesperia* xi (1942) 386. Similar types are listed in *BMCatalogue 218*, Nos. 815–816.

**24 Standing woman,** from Boeotia, mid-fifth century B.C.

The figure stands on a high rectangular base, with her left leg carrying the weight, whereas the right is relaxed. Her arms, hardly visible, hang along the sides of her body, and are held closely against it.

She wears a *peplos* with *apoptygma* (see No. 20), treated with broad tube-like folds down the side of the weight-carrying leg, while on the right side it is left plain. Her breasts are clearly defined and modelled underneath the garment. Her hair is parted down the middle, and waved in thick zig-zags round the face. At the back of the head she wears a *sakkos* (cf. No. 20), which terminates in a point. Her features are well modelled, long straight nose, full lips slightly parted, and eyes with upper and lower eyelids indicated. The treatment of this figure calls to mind Hippodameia from the East pediment of the temple of Zeus at Olympia, as well as the Athena of the Augean stables metope.

1888.101. Presented by A. J. Evans. H. 27.2 cm. Base 6.0 × 8.0 cm. Clay orange with traces of white slip and colour. Front moulded, with vent in the back.

Lit.: T. B. L. Webster, *Greek Terracottas* (London, 1951) 19–20, pl. 23*b*; V. H. Poulsen, *Der Strenge Stil*, (Copenhagen, 1937) 54, fig. 31.

Similar types are discussed in: *Louvre* i, 82 Nos. C2 and C3; For the date: Poulsen *op. cit.*, 53–54. Olympia sculpture: B. Ashmole and N. Yalouris, *Olympia, the Sculpture of the Temple of Zeus* (London, 1967) fig. 19.

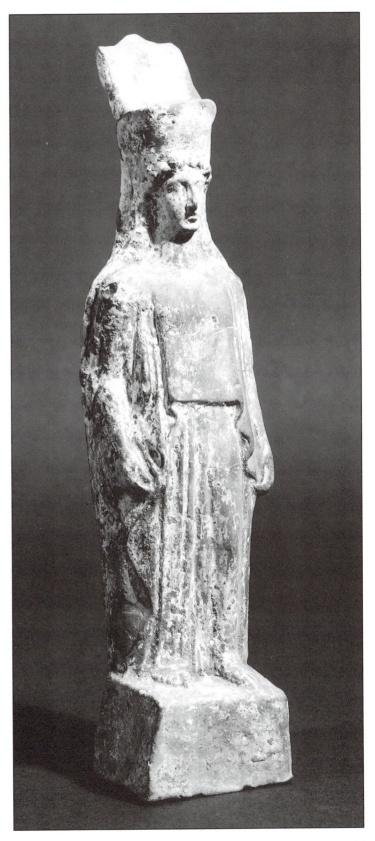

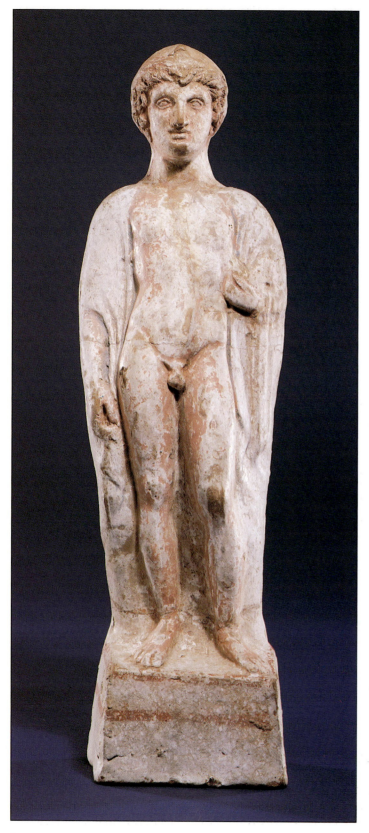

## 25 Standing youth, from Boeotia, mid-fifth century B.C.

The youth is shown standing frontally on a high rectangular base with his weight on his right leg, while his left is flexed and pushed slightly forward. His right arm hangs along the side of his body lifting part of the drapery. A cock rests in the crook of his left arm. Over his shoulders and down the sides falls a short *himation* in the form of a shawl, treated in rather summary folds, leaving the front of the body naked. The anatomical details betray a particular firmness – which is perceptible on all the early examples of the type – with the articulation of detail, such as the treatment of the abdominal muscles, the clavicles and the iliac crest, especially well defined; one can almost perceive a slight *déhanchement* of the right hip. The facial features are very carefully indicated, particularly the upper and lower eyelids, straight nose, a low forehead and a round chin. The medium-length hair appears to cover the ears, and is treated in curls down the sides, with a braid knotted over the forehead. This figurine belongs to a common Boeotian type popular in the fifth and fourth centuries B.C. as shown by the excavations at Rhitsona, Thebes and the Thespian Polyandrion. It has also been suggested that the cock may be an offering to an underworld deity. The unity of these figures and their similarity to subjects on grave *stelai* have led scholars to believe that these terracottas possibly represent the heroised dead. The stance and proportions of these reduced figurines echo the Omphalos Apollo, whereas the hair style is reminiscent of the Chatsworth head in the British Museum.

Whether the prototype came from Attica, as has been proved convincingly by D. B. Thompson for the Tanagra figurines, or whether the sole way of influence lay within the range of free-standing sculpture, is difficult to say for certain. However, as Boeotia always looked towards Attica for inspiration one may tentatively suggest that this type may have originated there too.

1893.96. Bought. H. 28.8 cm. Base 4.7 cm. Clay yellow ochre. Moulded front with very large rectangular vent at the back. Remains of white slip and pink colour for the flesh, also red on the hair, on

the *himation* and on the base, and red band round the upper edge of the *himation*.

Lit.: *Report* 1893, 6; Winter, i, 182, 4; V. H. Poulsen, *Acta Archaeologica* viii (1937) 77–9. Other examples of the type are listed and discussed: *BMCatalogue* 220–221 Nos. 825 and 828; *Louvre* i, 95, No. C68; B. Schmaltz, *Terrakotten aus den Kabirenheiligtum bei Theben* (Berlin, 1974) 45–49.

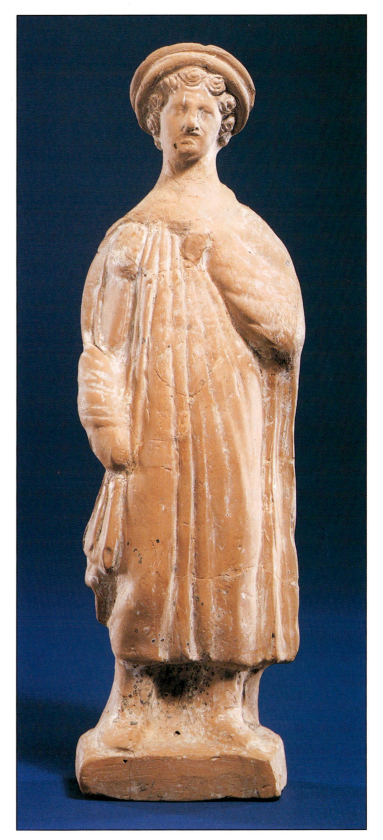

## 26 Standing boy, from Boeotia, fourth century B.C.

The young boy is represented standing on a small rectangular base, his weight on the left leg, while the right is slightly flexed. He is wrapped in the *himation* which he wears fastened on the right shoulder over a *chiton* with small sleeves. The *himation* covers both shoulders and falls straight below the knees, one edge being wrapped round the right forearm in a bunch, from which a series of zig-zag folds hangs by the side. His left arm is bent and rests on his chest. The treatment of the drapery is very summary, with a few deep folds down the front. He appears to be wearing short boots. On his head he wears a circular crown over which a round hat is placed. The hair is treated in a series of whorls round the face. The features are almost rubbed away.

1926.553. H. 21.6 cm. Clay yellow ochre. Moulded front with circular vent on the back. Remains of white slip.

Unpublished. A similar example from Livadhia, Boeotia: *Louvre* iii, pl. 38*a*. Tanagra: Higgins, *Terracottas*, pl. 45*e*.

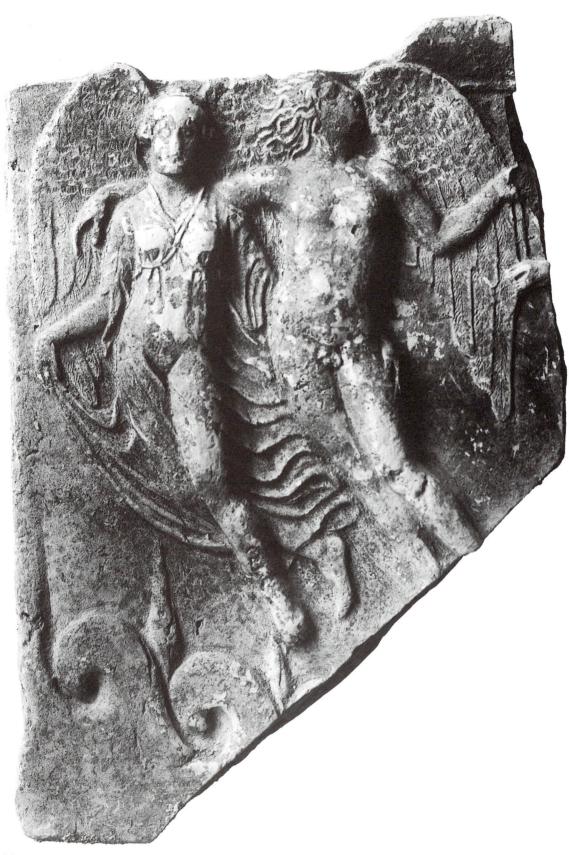

**27  Relief with Eros and Psyche,** from Taranto, *c.* 430–410 B.C.

This relief fragment, probably once part of an *arula* (see Nos. 19 and 58), shows two winged figures flying over the waves, which are shown as stylised curves, between which some arrow-like forms are represented diving; perhaps these are meant to represent dolphins. Only a small part of the crowning moulding remains above the Eros' left wing. The iconography of this piece is well-known, as many complete reliefs have been found. On our piece the third figure on the left, Aphrodite, is missing. Only her outstretched right hand which possibly held reins, can be seen against Eros' wing. On the right, Eros is shown naked with outspread wings and backward-flowing locks of hair treated like flames. His outstretched left arm possibly held some object, maybe an apple (?). His right arm rests on the shoulders of his young female companion, together with whom he once pulled Aphrodite's chariot. The pose is very reminiscent of the Himeros and Pothos pulling the chariot of the goddess on a *hydria* by the Meidias Painter.

On his right, the young girl Psyche (?) is clad in a transparent *chiton* which clings to her body-forms as the breeze blows against it. It is held by a fine criss-cross band between her breasts, which in turn is tied at the back. The treatment is like that of Selene's torso from the East pediment of the Parthenon. With her right hand she lifts the hem of her garment, while her left arm is placed around Eros' hips and her hand rests on his thigh. The treatment of the wings is very realistically rendered, with their upper part incised in the form of scales as if the artist were trying to produce a bronze-type effect of incision in the clay, and the lower part incised with fine wavy lines imitating feathers. In contrast, the folds of the drapery are rather monotonous and lack any real life in their treatment. Both these elements, however, offer a rich background to the figures, against which the upper part of their bodies, turned to face the spectator, stand out in relief. The features unfortunately are rather rubbed, but the facial fleshiness so characteristic of South Italian coroplastic style is still in evidence. Both treatment of drapery and modelling of the bodies point to a date in the last quarter of the fifth century B.C.

1886.668. A. J. Evans gift. H. 21 cm. W. 15.9 cm. Clay cream with remains of white slip.

Lit.: A. J. Evans, *JHS* vii (1886) 33, pl. 63; E. Petersen, *Römische Mitteilungen* xvi (1901) 77, fig. 3; E. Jastrow, *Opuscula Archaeologica* ii (1941) 7, pl. 5*a*.

The Meidias Painter's *hydria:* P. E. Arias, M. Hirmer and B. B. Shefton, *A History of Greek Vase Painting* (London, 1962) pl. 217. Selene: B. Ridgway, *The Severe Style in Greek sculpture* (Princeton, 1970) fig. 15.

**28  A boat,** from Taranto, late fourth century B.C.

This clay model of a boat, probably votive, has a curved stern ending in what looks like a bird's beak. The depression near the prow may be an opening for the oar. The lower part of the vessel is delicately ridged and the hull is modelled in a gentle concave form.

A very similar model boat was found in Gela dating from a context of *c.* 300 B.C. Both examples recall a bronze vessel of the Norman Davis Collection in the Seattle Art Museum dating from the fourth century B.C.

1886.713. H. 5.7 cm. L. 25 cm. Clay pale buff, with remains of pink and black.

Lit.: A. J. Evans, *JHS* vii (1886) 34, pl. 63.

The Gela boat: P. Orlandini, *Archeologia classica* ix (1957) pl. 72, 1. Seattle boat: D. G. Mitten and S. Doeringer, *Master Bronzes from the Classical World* (Mainz, 1967) 143, No. 148.

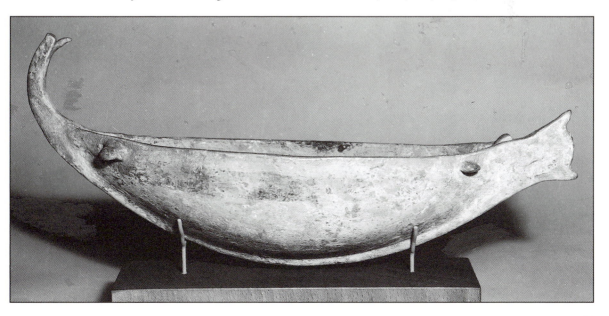

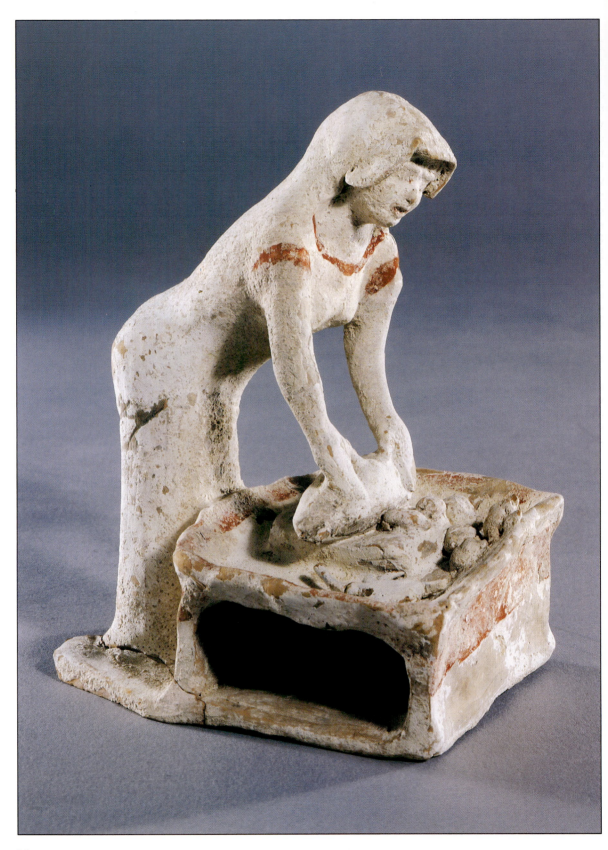

**29 Woman kneading bread,** from Aulis, *c.* 500–475 B.C.

This is certainly a genre composition, one of the commonest among the archaic types, especially from Boeotia. A woman wearing a short-sleeved *chiton* is bending over a rectangular stove (?) suggested by the opening on the side. She appears to be kneading bread on top of a square slab, which is placed in the middle of the trough, round which various animals are shown: tortoise, scorpion and a few rounded bits of dough, possibly buns. Her head is moulded whereas her body is hand-modelled. The arms are cylindrical, while the hands are treated flatly with only the thumb clearly defined. She wears a hood over her head which hides most of her hair. The features are rather rubbed. Her plain *chiton* is only decorated with a band of red paint round the neck and sleeves. A similar red band decorates the trough. Though this class of genre composition has yielded a fair number of women kneading bread, so far as I know our figurine is unique. The nearest parallel is a representation of a communal bakery in the Louvre, where eleven women are shown in a row kneading to the sound of a flute player, datable in the last quarter of the sixth century B.C.

G.39. H. 14.2 cm. W. 11.5 cm. Clay pinkish tan with remains of white slip and red colour.

Lit.: *Report* 1899, 16; B. A. Sparkes, *JHS* lxxxii (1962) pl. 8. The Louvre bakery: *Louvre* i, 20, B116, pl. 15.

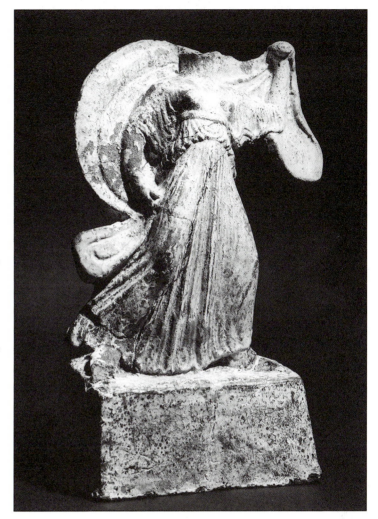

**30 Fleeing woman,** probably from Boeotia, late fifth century B.C.

On a high rectangular base a young girl moves rapidly towards the right. She wears a long sleeved *chiton* with a *kolpos*, which is held in place by a large flat belt under her breasts. The body-forms are well modelled and can be easily discerned underneath the drapery. Between her stretched legs hangs a mass of vertical string-like folds. A large veil held by her extended left hand and hanging by her right side is blown by her swift motion behind her back, thus surrounding her body in a halo. Her head is missing, but from other extant complete figurines belonging to the same type one may suppose hair parted in the middle and pulled at the back in crinkly waves, with two little horns at the top. A variant of this type has been found in Halae and dated between 390–350 B.C.; another one from Halicarnassus is even closer to our Boeotian type. As it would be highly unlikely to find a Boeotian influence in Halicarnassus and vice-versa, Higgins has suggested that both versions go back to a common source, most probably Attic.

1958.281. A. G. B. Russell bequest. H. 31 cm. Base 7 cm. Clay pale red with remains of white slip. On the back a regular vent, open beneath.

Lit.: *Report* 1958, 218. The Halae piece: H. Goldman and F. Jones, *Hesperia* xi (1942) 401, No. 18, pl. 9; Halicarnassus: *BMCatalogue*, pl. 60, No. 420.

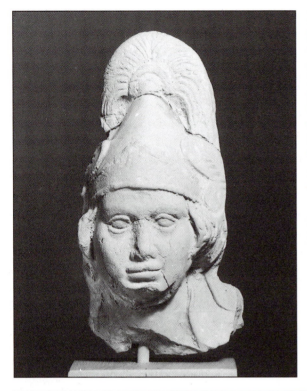

### 31 Head of Athena, from Taranto, *c.* 425–400 B.C.

She is shown wearing a helmet with a floppy crest and a well defined edge. Its cheek pieces are raised above each ear. The type of helmet is the so-called Phrygian. Her hair, treated in separate strands, hangs on either side of her face. The face is fleshy and round, with thick lips which give it a rather sulky expression. The large eyes are heavy-ringed. The type represented by our figurine recalls the Athena on the Syracusan tetradrachm of Eukleidas. A similar Athena can also be seen on an Apulian bell-crater in the Ashmolean representing the Judgement of Paris.

1886.657. H. 10 cm. Clay cream.

Unpublished. Similar helmet: F. von Lipperheide, *Antike Helme* (Munich, 1896) fig. 148. Syracusan tetradrachm: C. M. Kraay and M. Hirmer, *Greek Coins* (London, 1966) figs. 111–112. Ashmolean bell-crater: M. Vickers, *Greek Vases* (Oxford, 1978) No. 68.

### 32 Horse's head, from Taranto, *c.* 400 B.C.

A great number of moulds of horses' heads have been found, showing the variety of the Tarantine coroplastic master's art. One of the early examples of this series is the head in Naples, whose simple modelling dates it to the last quarter of the fifth century B.C. Our example is of very high quality and reminiscent of the horses on the Parthenon. Its shaggy mane is treated in thickly

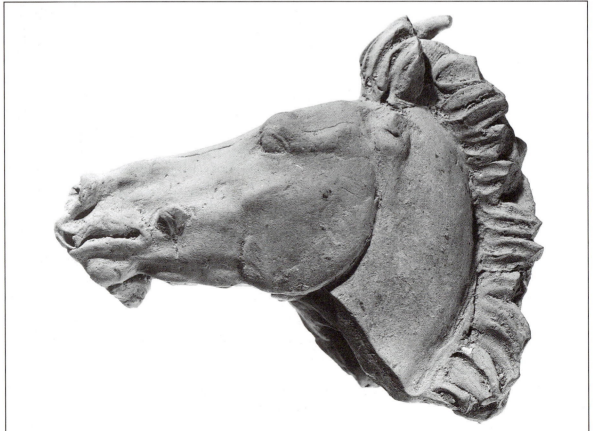

modelled fiery locks, which stand upright above its forehead. Its left ear is broken off. The articulation of the lower jaw, the musculature of the mouth, the modelling of the nostrils and treatment of eye are all characteristic of the late fifth century or early fourth century B.C.

It is difficult to imagine what was the purpose of heads of this kind, of which several examples are known. One suggestion is that they might have been part of a heroised rider's relief, similar in stance and attributes to those represented on a fragment from Taranto and on a fragmentary protome in the British Museum.

1886.650. A. J. Evans gift. H. 9 cm. L. 11 cm. Clay pale cream.

Unpublished. The Naples head: A. Levi, *Le terrecotte figurate del Museo di Napoli* (Florence, 1926) 35, fig. 36. Parthenon horses: M. Robertson and A. Frantz, *The Parthenon Frieze* (London, 1975) North side, esp. xxxvii, 114. Heroised reliefs in Taranto: R. Bartoccini *Notizie degli Scavi* xiv (1936) 168–9, figs. 76–77; in London *BMCatalogue*, 361, pl. 181, No. 1327.

## 33 Woman standing, *c.* 400–345 B.C.

The figure stands on a semi-circular base, flanged at the top and bottom, with her right leg flexed, while the left leg carries the weight. She is shown wearing a long *chiton,* tied with a belt round her waist and treated in fine string-like folds. The *himation* wrapped round her body is worn as a veil over the back of her head, and secured on the left of the waist by her left hand held akimbo. Her left arm is entirely muffled in the drapery. The right arm is bent up sideways from the elbow, and the hand at shoulder level holds out the *himation* as if adjusting it. Her hair parted in the middle is treated in a coil round the face, and drawn up into a high top knot. She has a full and round face. The right eye is rendered very carefully with upper and lower eyelids indicated, while the left is rubbed off. This type must go back to a sculptural prototype, known in a Roman copy and identified as Demeter. It is also known by another variant as Leda, in the British Museum. The find-spot of our example is unknown, but to judge from the numerous examples of this type found in Boeotia, one could reasonably assume that this one too came from there.

1927.2117. E. R. Price bequest. H. 27.5 cm. Clay pale orange. Remains of white slip and blue colour. A big rectangular vent on the back.

Lit.: *Report* 1927, 13. Similar examples from Boeotia: *BMCatalogue* 230 pl. 123, No. 862.

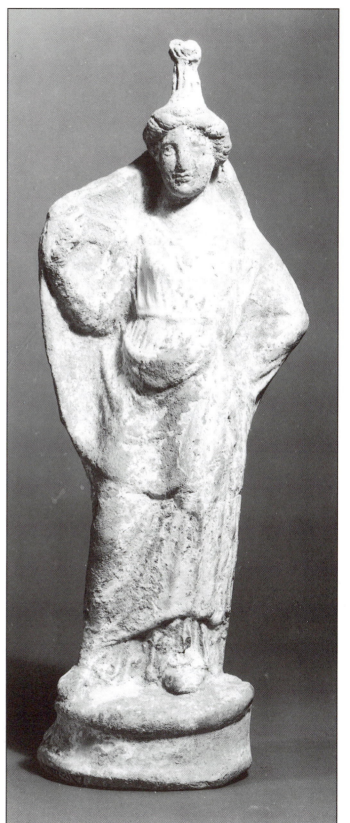

**34  Reclining man,** from Taranto, *c.* 400–350 B.C.

The figure is shown reclining on the left side with his right arm resting along his body while he leans on his left elbow. These figures were made by means of moulds, and belong to a well-known Tarentine series whose theme remained unchanged for more than three centuries – from the mid-sixth century B.C. until at least the third century B.C. Their iconography suggests that they were votive offerings made to underworld divinities. But even today there is no agreement as to which cult they belonged.

In our example, the modelling of the musculature of the torso is very precise with a naturalistic rendering and may be compared to some of the sculptures of the early fourth century. One can clearly imagine the abdominal muscles bulging upwards as he takes a deep breath. Only part of the drapery remains, but it once covered the lower part of the body and left arm. Its surface is blobby and may suggest a woolly material. The head is set straight on the neck with an upward-looking gaze, somewhat distant but serene. He has a long pointed beard treated in individual short wavy strands, and a long moustache frames his full lips. The hair also is rendered in short symmetrical locks on either side of the forehead, and held by a large fillet whose extremities once fell on either shoulder (only part of one of them remains above the left shoulder). A stippled floral crown is decorated with three large six-petalled rosettes and a central palmette (broken off). The cheeks are flat and clearly delimited by the beard, and the nose is long and straight.

1910.768. J. R. Anderson bequest. H. 15.5 cm. Clay light buff with an inner reddish tint.
Unpublished. The genre is discussed by B. Neutsch, *Römische Mitteilungen,* 66–68 (1960–61) 150–163.

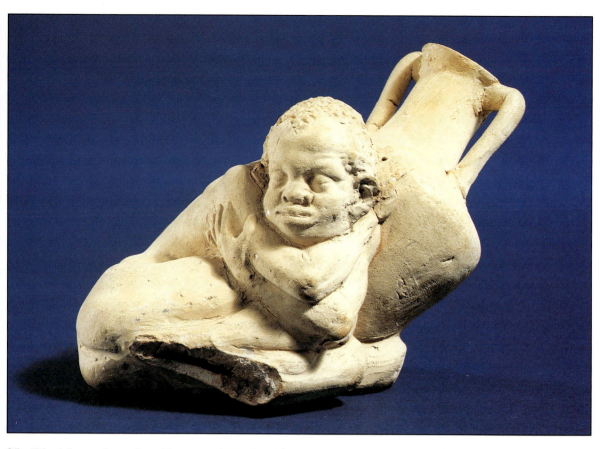

**35** **Black boy asleep,** from Taranto, *c.* 350–325 B.C.

This is the best example of the type, a masterpiece of the Tarantine coroplastic art. A small figure of an Ethiopian boy, possibly a little slave, is shown crouching at the base of a wine-jar and resting the upper part of his body against the vase's belly. He is curled up like a snail, with his arms clasped round his chest, happily asleep, perhaps either from exhaustion or the effects of the jar's contents.

Facial characteristics of the negroid type are sensitively and accurately rendered: a large flat forehead, with a flat snub nose, thick lips slightly parted, and short curly hair treated almost like a lamb's fleece. The eyes are firmly shut, with a slit where the upper and lower eyelids meet. His left ear is shown large and sticking out. The hands are effectively treated. The facial features are very close to those of a bronze found at Chalon-sur-Saône, which Hausmann dates to the same period as our example; it is another example of an Ethiopian child, possibly an itinerant musician. Moreover, the naturalistic rendering of his muscles and anatomy, particularly the bone structure of the rib cage and vertebral column underneath the skinny flesh, are striking in conveying an undernourished state, the skin creases at the point where the body is bent into two halves calling to mind once more the

Chalon bronze. On these grounds, Hausmann assumed that both these works were contemporary and shared a common origin in the Hellenistic art of Egypt. I know of no similar figurine from Egypt but similar examples have been found in Reggio di Calabria, as well as in Olbia. It is very probable that the prototype may have been Egyptian, for as we know relations between Egypt and Apulia during the Hellenistic period were very close. But both the clay of our figurine and its workmanship, which is certainly of a very high standard, betray its Tarantine origin, and the type may have gone to Egypt via Taranto rather than the other way round.

1884.583. H. 6.3 cm. Clay light buff with a reddish tint.
Lit.: A. J. Evans, *JHS* vii (1886) 37–38, pl. 64; A. W. Lawrence, *Later Greek Sculpture* (London, 1927), pl. 3; G. H. Beardsley, *The Negro in Greek Civilisation* (Baltimore, 1929), 90, No. 197; C. W. Lunsingh-Scheurleer, *Grieksche Ceramick* (Rotterdam, 1936) pl. 56, No. 178; Ashmolean Museum, *Summary Guide to the Department of Antiquities* (Oxford, 1931) 90; V. R. Grace, *Amphoras and the Ancient Wine Trade* (Princeton, 1961) fig. 9; U. Hausmann, *AM* lxxvii–lxxviii (1962) 255–281, pl. 78. 3–4; F. M. Snowden, Jr., *Blacks in Antiquity* (Cambridge, Mass., 1970) fig. 46; A. Adriani, *AM* xciii (1978) 124, pl. 44, 1–2; L. Bugner (Ed.), *The Image of the Black in Western Art* i (New York, 1976) 206, figs. 262–3.
The Chalon-sur-Saône statuette: A. Adriani, *loc. cit.*, pls. 39, 3 and 40, 1–2.

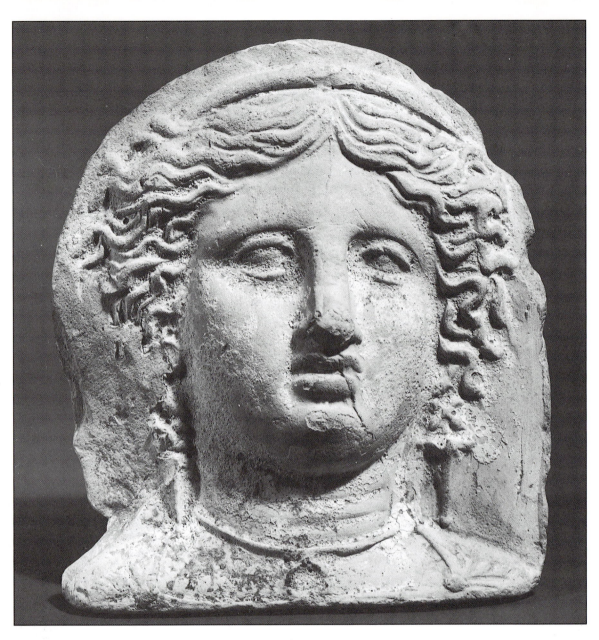

**36 Woman's head,** from Taranto, *c.* 400–375 B.C.

This antefix shows an expressive face of a female, slightly turned to the left. The face is rather full, with a heavy chin and a sensual mouth, with slightly parted lips. The eyes are large and heavy-lidded giving a slightly distant expression. The lower eyelid is indicated, while the pupils are incised. The hair is parted and waved regularly on either side of the face, treated in wildly flowing strands. A cylindrical diadem keeps it in place. An Ionic *chiton* is suggested by buttons at the shoulders. This type of head recalls those on Syracusan coins, which first appear towards the end of the fifth century, and those on coins from Croton dated to *c.* 360 B.C.

She also wears a necklace with a crescent-like ornament hanging from it. Two Venus rings are indicated on her neck, and her earrings are in the form of an inverted pyramid suspended from a cross.

Despite the fact that these heads are known through many examples, there is no clear indication as to whom they represent, and there is no evidence that any deity is shown.

1886.745. Gift of A. J. Evans, H. 19.6 cm. W. 17.8 cm. Clay pale orange.
Unpublished. A similar head: *BMCatalogue* 369 pl. 190, No. 1361. Syracusan coins: C. M. Kraay and M. Hirmer, *Greek Coins* (London, 1966) pl. 44, No. 122, pl. 45, No. 123, pl. 94, No. 270.

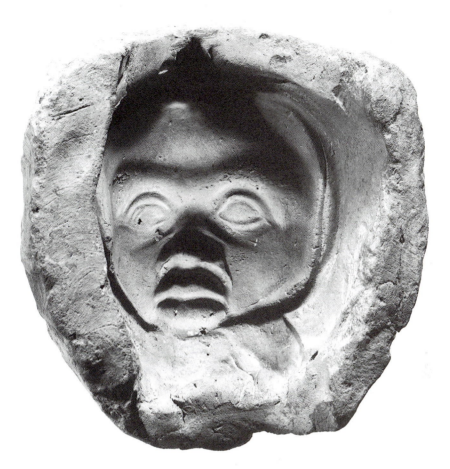

**37 Mould for the head of a black,** from Naucratis, Egypt, fifth century B.C.

This mould represents the front part of a negro's head. The physical characteristics of the negroid type are very marked: a flat snub nose, thick lips and large wide-opened eyes with upper and lower eyelids indicated. He seems to be wearing some sort of hood, which frames his face and covers his chin, possibly a worker's hat or an oriental one. A somewhat similar head, belonging to the same period, comes from Salamis. They are both, however, probably later than a mask from Agrigento.

Aeschylus was the first Greek writer to locate Ethiopians definitely in Africa, and we know from Herodotus that Ionian and Carian mercenaries served under Psammetichus I (663–609 B.C.). By the sixth century B.C. Greeks were well established in Naucratis where they must have acquired a sound knowledge of the negroid type and interest in it. A somewhat similar type also appears on vases.

G.96. H. 14.3 cm. W. 13 cm. Mould clay reddish.

Lit.: F. M. Snowden, Jr, *Blacks in Antiquity* (Cambridge, Mass., 1970) 221, fig. 78, *a–b*.

The Salamis head: J. Sieveking, *Sammlung Loeb* i (Munich, 1916) pl. 29 *a–b*. Agrigento: Snowden, *op cit.*, 38–39, pl. 7, *a–b*.

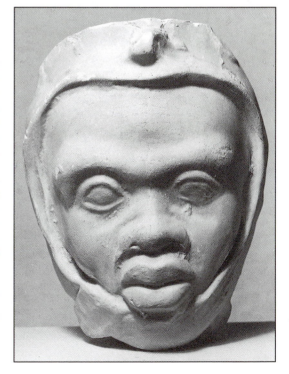

**38 Impression from mould for the head of a black.**

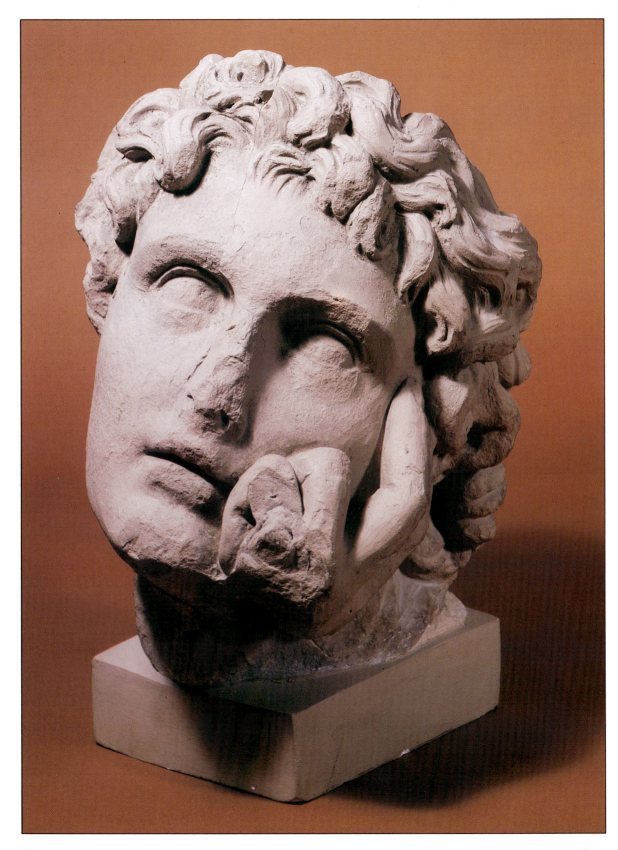

**39  Head of a youth,** found on the Esquiline, Rome, *c.* 350–325 B.C.

The youth has his head resting in the palm of his left hand in a reflective attitude, but with a melancholy look in his eyes. His gaze is certainly directed upwards, as if to focus upon some distant object. The right side of the face is slightly larger, as his head inclines to the left. The cheek is broad and flat. The oval of the face is short and heavy, dominated by the deep-set eyes and small chin. The forehead is low and shallow, and rounded off towards the temples. The lower eyelid is faintly indicated, while the upper is subtly modelled. The nose, despite its poor condition, shows the nostrils slightly dilated. The mouth is full with parted lips. The ear is simply indicated by a deep depression between the locks. The treatment of the hair is very remarkable. The locks are short but thick, and modelled individually in curls. This technique is reminiscent of both marble and bronze hair treatments. The hair at the back of the head is less well executed, but the locks which fall on the nape are carefully modelled. This head was most certainly executed by an artist who was profoundly influenced by the Attic tradition of the fourth century B.C.

Both in the hair treatment and expression this head shows close affinities with the Meleager in the Villa Medici, derived from an original assigned to Scopas. However, one can also detect similarities, particularly in the treatment of the hair, with the 'Aberdeen head' in the British Museum which shows more Praxitelean features than Scopaic. To attempt to assign this head to the style of any particular great master would, therefore, seem inappropriate. It was certainly created either by an immigrant Attic artist or by one trained in the tradition of the fourth century masters.

The other puzzling question is its place of origin. Was it a free standing funerary sculpture, or part of a high relief figure in a *naïskos* (as the temple-like settings of fourth-century Greek tombstones are called)? Deonna has proposed a possible reconstruction by analogy with a Tanagra terracotta, but if one accepts the hypothesis of a youth in heroic nudity then one ought to imagine him shown in a similar pose to the youth on the Ilissos stele. I find the hypothesis of the head being part of a pedimental decoration difficult to believe, and think it more plausible that it belonged to a tomb-monument.

S.1. Fortnum bequest. H. 0.294 cm. Clay light buff. Hollow.

Lit.: L. R. Farnell, *JHS* vii (1886) 114–125, pl. A; Burlington Fine Arts Club, *Catalogue of Greek Ceramic Art* (London, 1888) 96, No. 249 (illustrated); E. La Rocca in *Roma Medio Repubblicana, aspetti culturali di Roma e del Lazio nei secoli iv e iii a. C.* (Rome, 1973) 197–200 (further bibliography p. 199), pls. 44–45; M. Vickers, *The Roman World* (Oxford, 1977) 101.

The Villa Medici Meleager: A. F. Stewart, *Scopas of Paros* (Park Ridge, N.J. 1977) pl. 44. The Aberdeen head: *ibid*, pl. 46 *c–d.*

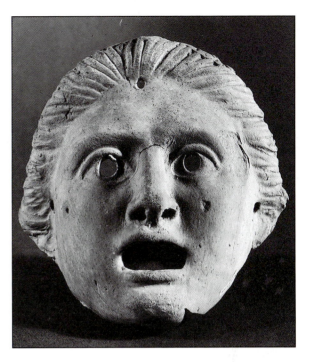

**40  Tragic mask,** from Naples, second century B.C.

Life-size. The eyes are modelled, with upper and lower eyelids indicated and with circular holes cut to indicate the iris. Suspension holes were also cut above the forehead and on either side of the face, possibly in order to hang it on a wall as decoration. Such decorations have been attested in both Priene and Delos. The mouth with well modelled lips is gaping wide. The nose is straight with large nostrils and the chin small and rounded. The hair is treated in a heavy coil around the head, possibly indicating the common type of a slave recognizable by the characteristic headdress of the *speira.*

This type of mask probably also appears on two reliefs, one in Naples showing a comic scene, the other in the Lateran depicting Menander examining a similar mask.

S.1*. Fortnum bequest. H. 17.9 cm. W. 18.9 cm. Clay light reddish.

Unpublished. Similar masks are discussed by C. Robert, *Die Masken der neueren attischen Komödie* (Niemeyer, 1911) figs. 85 and 96; T. B. L. Webster, *Monuments illustrating New Comedy* (London, 1969) 5–14.

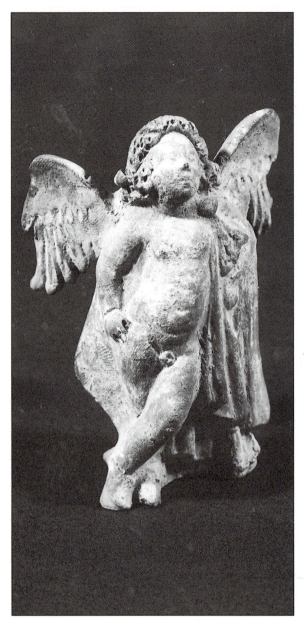

**42 Elderly comic actor,** from Attica, *c.* 375–350 B.C.

The actor stands on a small square base with his weight on his left leg whereas the right is slightly flexed forward. He wears a long *himation* wrapped tightly round his body and falling down to his ankles. The right arm is bent and rests against his chest. the left hangs along the side lifting one edge of the drapery in its hand. He is rather fat and his belly protrudes conspicuously forward, circumscribed by two rope-like folds. He wears a stippled crown and the mask-like face wears a grimace. His short beard and the drooping moustache are treated in separate locks. I have been unable to find a parallel for this figure.

1939.349 Formerly in the collection of E. P. Warren. H. 11.5 cm. Reddish clay with remains of white slip.

Lit.: *Report* 1939, 15, pl. 5; Ashmolean Museum, *Summary Guide to the Department of Antiquities* (Oxford, 1951) 53, pl. xxxiii, D.

**43 Elderly comic actor,** from Attica, *c.* 375–350 B.C.

He is shown standing on a square base, with legs together. He wears a short *chiton*, possibly with a fringe, and a *himation* wrapped round both shoulders and left arm. One edge held against his fat belly hangs down the left side in a mass of folds. The right arm is bent and rests on the edge of his beard. The phallus appears to be looped while the accurate treatment of the knees seems to indicate that he is not wearing tights. The mask-like face belongs to Webster's Mask E Group. The hair is scanty and fairly short at the back thus exposing the ears. His beard is short and bushy, the nose short and the mouth is shown straight but wide open. Perhaps this is a figured representation of Pollux's play *Protopappos*, which is found already on a fifth century Attic *chous* and is also attested on a Phlyax vase of the fourth century B.C.

1939.350. Formerly in the collection of E. P. Warren. H. 12 cm. Clay buff with remains of white slip, traces of red on the head. Broken across legs and restored.

Lit.: *Report* 1939, 15, pl. 5; T. B. L. Webster, *Monuments illustrating Old and Middle Comedy*, 3rd edn; *Bulletin of the Institute of Classical Studies*, Supplement xxxix (1978) 74, AT36, pl. 10b.

**41 Eros,** from Taranto, *c.* 300 B.C.

The little winged Eros is shown as a chubby child standing on his right leg with the left flexed and crossing over. The right arm rests on his hip, while the left is muffled in the drapery. He is naked but for the *chlamys,* which is buttoned on his left shoulder and hangs down the side in vertical tube-like folds. The roundness of his face is even more emphasized by the curly locks which frame it on either side and fall freely onto the shoulders. He wears a stippled floral crown. The features are rather rubbed.

1886.720. H. 7.5 cm. Clay buff with a reddish tint. Back not modelled with small round vent.

Lit.: A. J. Evans, *JHS* vii (1886) 37; Winter, 34, 9.1.

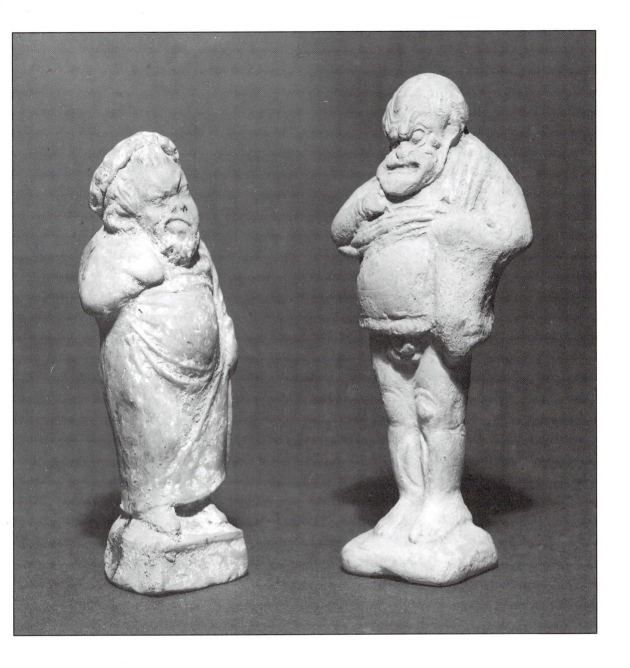

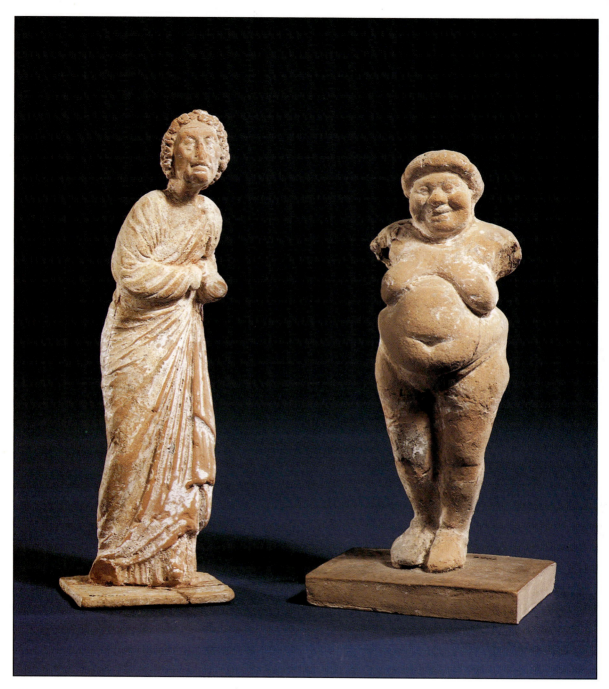

**44 Thin woman,** from Boeotia, late fourth century B.C.

Figure of a thin old woman dressed in a fine *chiton* of which only the hem is visible under the *himation*. The *himation* is firmly wrapped round her body and arms, with one edge tucked under her crossed arms and hanging in a series of zigzags down the left side. The treatment of the folds is fine and delicate. The left leg appears to carry the weight, while the right is slightly flexed. She stoops forward thus accentuating the impression of old age. Her face is rather thin and her cheeks sunken. The lips droop at the edges and the pointed chin sticks out. The forehead is marked with a few wrinkles and the eyes have a sleepy expression. The hair is treated in short curls falling to shoulder length.

1909.841. H. 14.5 cm. Clay reddish with remains of white slip. Stands on a fine plaque. No vent.

Unpublished.

**45 Fat woman,** late fourth century B.C.

This obese figurine stands almost frontally with her legs pressed tightly together and the right knee slightly flexed. The arms are missing. Her round full face with its double chin is pressed between her shoulders with a slight forward tilt, and no neck is visible. Her hair is coiled around her head. A similar figurine from the Demeter Cistern in the Athenian Agora, and showing the same obesity, is thought to have been a doll on account of her articulated arms, but may represent a hetaira. The features of our figurine are rather coarse, with her full, grinning mouth, her large nose and pig like eyes embedded in fleshy cheeks.

1966.672. Beazley gift. H. 12 cm. Modern base. Clay red. Traces of white slip remain. Stands on a thin base (modern) with fore-part of left foot restored.

Lit.: Ashmolean Museum, *Select Exhibition of Sir John and Lady Beazley's Gifts* (Oxford, 1967) 165, pl. 81, No. 632; *Report* 1966, 16.

The Agora 'doll': D.B. Thompson, *Hesperia* xxiii (1954) 90, pl. 21, 2.

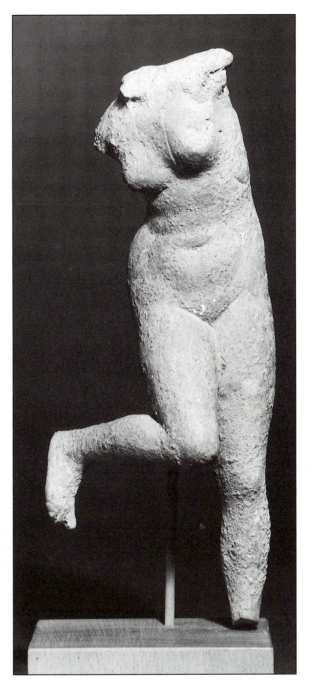

**46 Bathing Aphrodite,** from Taranto, *c.* 200 B.C.

This naked figure stands with the left leg carrying her weight, while the right bent at the knee is raised and lifted upwards. The upper part of her body slightly turns towards the flexed lower leg and stoops forward in a position recalling that of the Aphrodites binding or unbinding their sandal. The arms unfortunately are missing but the type is well attested among terracotta figurines and bronzes of this period.

The upper part of the body is slender, with small well-defined breasts. The hips, slightly heavier, give a more fleshy impression, particularly in the rendering of the belly's soft form, with a slight bulge below the navel.

The same type is found on a bronze coin of Aphrodisias in Caria and there may be some possibility that these figurines were inspired by the Aphrodite *Monoknemos* of Apelles referred to by Petronius.

1886.703 H. 18 cm. Clay pale orange. The head, both arms and the left foot are missing.

Lit.: A. J. Evans, *JHS* vii (1886) 36, pl. 64. Similar example: A. Hundt and K. Peters, *Greifswelder Antiken* (Berlin, 1961) 113, pl. 491 Nos. 62–63, with further bibliography.

**47  Hermaphrodite,** from Smyrna, first century B.C.

The figure is shown naked, standing on the right leg, while the left is flexed and pushed to the back. In the right hand is held a vase, while the left arm is raised. The movement of the body is composed of two wide curves forming an inverted 'S'. The hips are slender and the waist small with a slight *déhanchement*. The shoulders slant to the right with the head turned in this direction also; it tilts forward with the gaze down-ward. The proportions are rather slim and the musculature barely developed underneath the smoothness of the flesh; both recall in treatment the Marathon Boy. The head is small and rests on a tall slender neck. The features are delicately treated: a low triangular forehead with straight nose and full lips; and a small and rounded chin. The eyes with upper and lower eyelids finely indicated have pierced pupils and give the face a distant expression. The hair treated in the melon hair style has eight divisions and is drawn to a round chignon at the back. A sandal is shown on the surviving foot.

G.304. H. 27 cm. Clay orange with a fine shiny surface. No vent but modelling very careful. Left hand and foot missing.

Unpublished. Similar example: Winter, 365, 5.

**48  Female head,** from Smyrna, first century B.C.

The head most probably belonged to a large figure judging by its size. The surface is slightly chipped but on the whole its state of preservation is good. The narrow oval of the face is framed by the hair falling in thick locks on either side of the neck in a technique which recalls bronze work, while at the top it is piled up and tied in a bow knot characteristic of the Aphrodite and Artemis hair-styles. The forehead is low and triangular. The eyebrows lightly modelled over the large eyes with pierced pupils add a shade of melancholy to the otherwise distant expression. The eyelids are finely indicated, with the upper one a little heavy. The nose is long and straight, chipped at its tip, but with nostrils shown. The mouth is small and the fleshy lips are slightly open.

1911.9. H. 11 cm. Clay orange with remains of gilding on the face. Back modelled.

Unpublished. For bronze parallels, see *e.g.* M. Comstock and C. Vermeule, *Greek Etruscan and Roman Bronzes in the Museum of Fine Arts, Boston* (Greenwich, Ct., 1971) 437, No. 641.

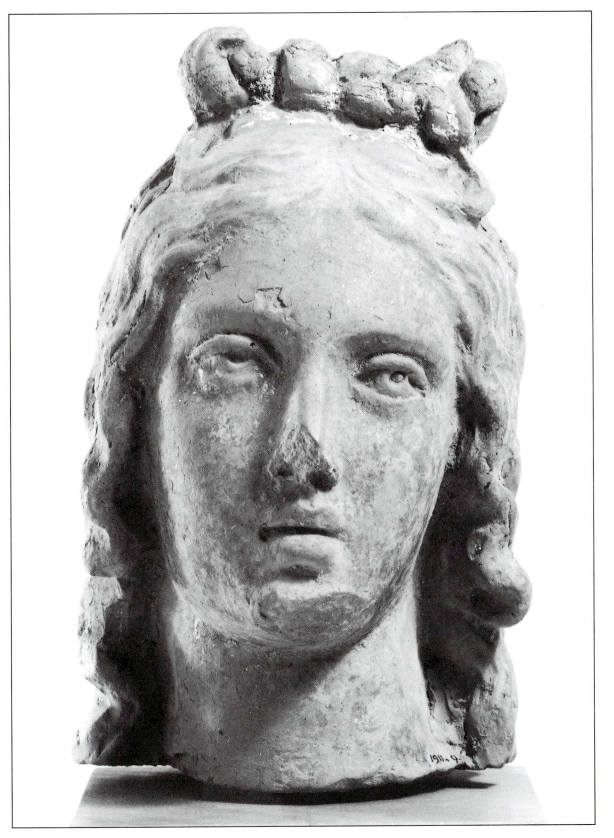

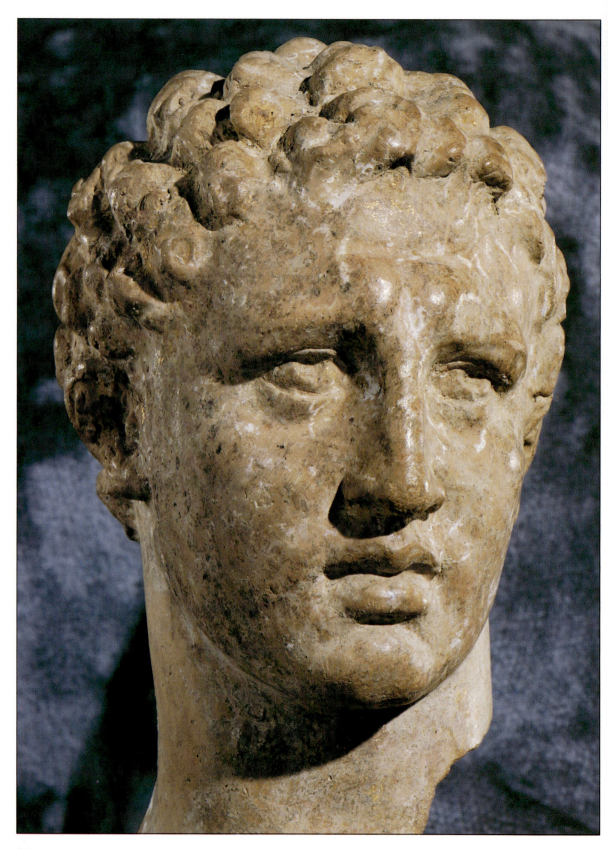

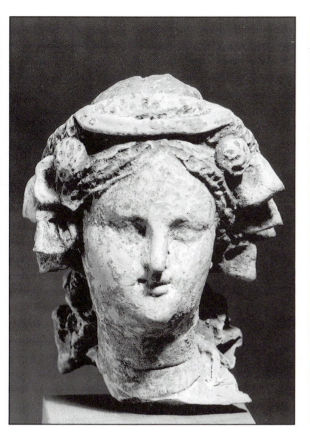 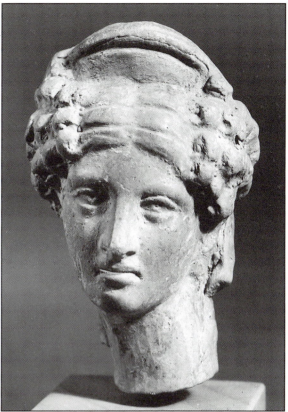

**49   Male head,** from Smyrna, first century B.C.

This head once belonged to a figurine of substantial proportions. The clay surface is well preserved and it shows remains of gilding. A somewhat frowning man is shown with his eyebrows knitted together over a slightly aquiline nose. The face is oval and has a small but forceful chin, with a distinct furrow under the lip. The mouth is full with well modelled lips, and the forehead narrow with a deep groove across it. The deep and close-set eyes have rather puffy lower eyelids. The hair is treated in curly locks and is modelled with great virtuosity. Lysippos' influence on this head is fairly evident particularly when one compares it to the head of the Agias at Delphi.

1911.8. H. 12 cm. Clay orange with remains of gilding. Back modelled carefully.
Unpublished. For similar head, see: *Louvre* iii, pl. 287*d* and pl. 222*b* and *d*.

**50   Wreathed female head,** from Taranto, late third century B.C.

A female head inclined to the left, set on a long neck with two Venus rings. The face is full and rather fleshy with a low triangular forehead and small chin. The nose is long and straight, the mouth full with parted lips. The hair is parted in the middle and treated in crinkly waves with long curls down the neck. She wears a thick

stippled crown above a wreath of ivy leaves and fruit, both made separately and attached. A flat fillet falls in a loop over the crown.

1886.709. H. 6.5 cm. Clay pale cream, remains of white slip. Back modelled.
Unpublished. For similar heads, see: *Louvre* ii pl. 204*g*.

**51   Female head, wearing a stephane,** from Smyrna, first half of the first century A.D.

Female head inclined to the left and set on a long thin neck. The face is a narrow oval with a well defined forceful chin. The straight nose has clearly outlined nostrils. The parted lips of the mouth droop at the corners, producing a sulky expression. The eyes with heavy eyelids have the pupils pierced. The hair, parted in the middle, is divided into three flat strands which end in a bank of curls on either side above the forehead. The hair is held in place by a high crescent-shaped *stephane* (diadem). This coiffure can be observed in Asia Minor as early as the time of the statue of 'Artemisia'. It reaches its heyday during the second century B.C., but continues to be popular down to the Roman period. Our head also wears earrings.

1910.715. H. 5.5 cm. Clay orange with traces of white slip. Back not modelled.
Unpublished. For similar heads, see: *Louvre* iii pl. 181*a–c*.

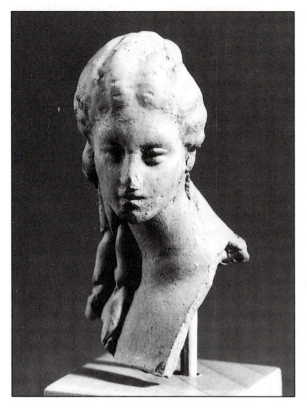

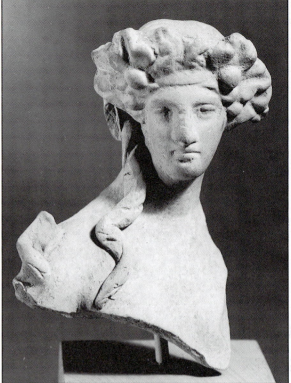

**52  Female head,** from Smyrna, *c.* 100 B.C.

The head is set on a long thin neck with part of the right
shoulder and chest remaining. It is turned and tilts
slightly to the left. Its shape is a delicate oval with a
small chin and triangular forehead. The eyes almost
appear to squint between the puffed eyelids. The nose
is straight but chipped at its point. The mouth is full
with parted lips. The hair is treated in the melon hair
style of ten divisions pulled at the back into a flat bun-
type chignon, and with two long twisted curls hanging
down over the right shoulder. She also wears earrings.

1910.711. H. 6.2 cm. Clay orange. Part of the left side is missing.
Unpublished.

**53  Head of Dionysus,** from Smyrna, *c.* 100 B.C.

The god is shown young, with a slightly effeminate
expression, turning a little to the right. His face, a thin
oval shape with a small round chin and a low forehead,
recalls a Praxitelean type. His nose is long and straight,
whereas his upper lip is thinner than the lower one. The
eyebrows, faintly indicated above the eyes with a heavy
upper lid, add a distant expression. The hair is pulled at
the back and forms a bun-shaped chignon on the nape,
from which a few locks escape and are treated in two
long curls down the neck and right shoulder. The head
is crowned with a thick crown of laurel leaves and fruit,
and held in place by a *mitra* over the forehead.

1910.710. H. 7.7 cm. Clay orange. Part of one curl is missing.
Lit.: *Report* 1911, 18. For similar heads, see: *Louvre* ii pl. 94*d–e;*
iii, pl. 274*b–c.*

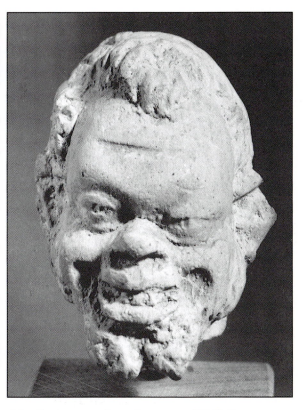

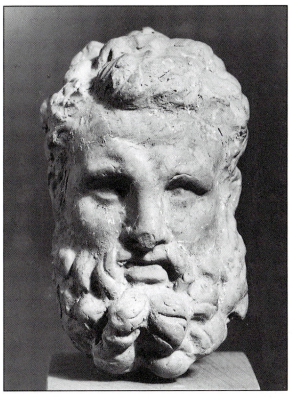

**54 Caricature,** from Smyrna, *c.* 100 B.C.

This head shows a caricature of a negroid type. The surface is slightly weathered and chipped in places. The face shows a sly grin which leaves the mouth open and allows a row of teeth to be shown between his thick lips. His snub nose and fuzzy hair betray his origin. His forehead is large with a deep furrow. The eyes with their hollow pupils have bags underneath; the left eyelid seems to droop over the eyeball, whereas the right one is modelled heavily. A ragged beard frames his chin.

1910.709. H. 3.3 cm. Clay orange.

Unpublished. For similar heads, see: *Louvre* iii pl. 214*g*, and pl. 319*h–j*.

**55 Head of Herakles,** from Smyrna, *c.* 100 B.C.

Herakles is shown bearded and wearing a moustache. The forehead is large and broad with a slight furrow running across it. The face is round and fleshy, particularly in the cheeks. The deeply set eyes have an upward gaze, overshadowed by the bulge of the eyelid. The pupils are incised. The nose is broad and the mouth full. On the upper lip there flourishes a thick drooping moustache. The hair is treated in separate short locks reminiscent of Lysippos's treatment of hair. The bushy beard is shown in thick long curls in a rather pictorial manner. This head is fairly close to one found in the Athenian Agora which D. B. Thompson wished to associate with a statuette of Herakles Epitrapezios from Alba Fucens. Since we know the Smyrna coroplasts were renowned for translating well known sculptures into reduced masterpieces, could our head perhaps echo a similar statue or perhaps one in another pose?

1911.31. H. 6.4 cm. Clay orange with remains of gilding.

Unpublished. For similar heads, see: *Louvre* ii pl. 220*f.* The Agora head: D. B. Thompson, *Hesperia* xxxiv (1965) pp. 34–71, pl. 18.

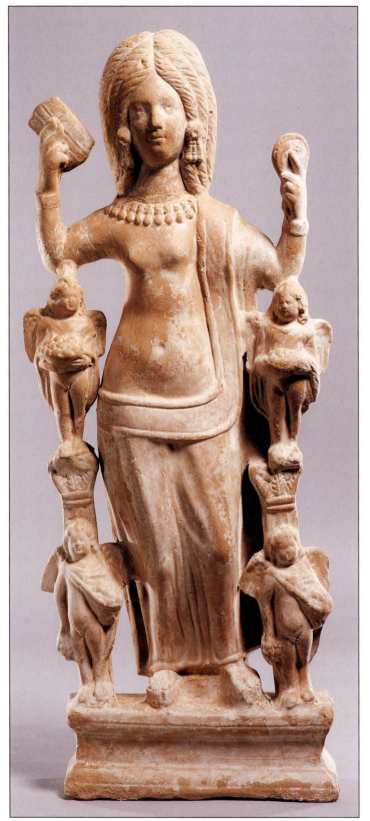

**56 Aphrodite at her toilet,** *c.* 200 A.D.

The goddess (if indeed the figure represents her, rather than a mortal woman in the guise of Aphrodite) is standing on her right leg, with the left flexed to the side, and is finishing her toilette. In her upraised right arm she holds a comb, and in her left a mirror, a motive which is well attested by numerous examples of Aphrodite in Greek art. She is clad in a long mantle with a large border, which leaves the upper part of the body bare; it is wrapped round her hips with one edge thrown over the left shoulder and hanging down her back. The modelling of the body is careful and the treatment of the drapery recalls free-standing sculpture. Her narrow shoulders and bust create a definite contrast with her large hips. She wears high-soled sandals.

A rich selection of jewellery adorns the figurine: a double row of beads hang round her neck, bracelets are worn on either arm and dangling heavy disc-earrings on her ears. Her hair is covered by a heavy lobed coiffure, parted in the centre, which almost certainly is a wig. On either side is a pilaster with a Corinthian capital, and in front of each stands a little winged putti draped with a short *chlamys* and carrying fruit in its fold. Above them another set of two putti resting their feet on the capitals are also carrying fruit in baskets. Recently a great number of similar statues were found in a row at Amphipolis, but with dolphins accompanying the goddess rather than putti.

1973.962. H. 59 cm. Reddish clay with traces of pink paint on eyes and feet.

Lit.: Sotheby, *Catalogue* May 14, 1973, pl. 9, No. 126; D. Strong and D. Brown, *Roman Crafts* (London, 1976) 104, fig. 185.

The type is fully discussed by W. Hornbostel, *Stiftung zur Förderung der Hamburgischen Kuntsammlungen Erwerbungen* (Hamburg, 1979) 32–33. The Amphipolis statuettes: *Archaeological Reports* 1978–79, 31, fig. 41.

**57  Seated youth,** from Boeotia, early third century B.C.

A youth clad in a *chiton*, the short sleeve of which can be seen through the opening of the *himation*, is shown seated on a rectangular base, possibly an altar. His *himation* is wrapped round his body and attached on the right shoulder, leaving the right arm bare, the hand resting on his lap holding an edge of the drapery. The left arm is muffled in the folds and leans on the base. The rope-like folds of the *himation* form a series of 'V's which start from the left shoulder and are distributed round the right arm. His hair is short and treated in short locks. On his head rests a round crown.

1967.742. Bought. H. 13.2 cm. Clay light cream. Traces of white slip and pink and blue colour. Base is attached. Feet missing. At the back a nearly square vent.

Lit.: *Sotheby Catalogue* 29 April 1967, Lot. 24, fig. 83; *Report* 1967, 17, pl. 4c. Similar example: Winter, 256, 5.

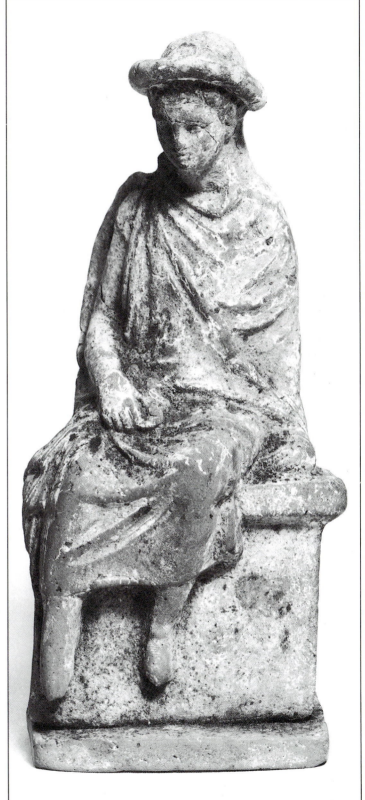

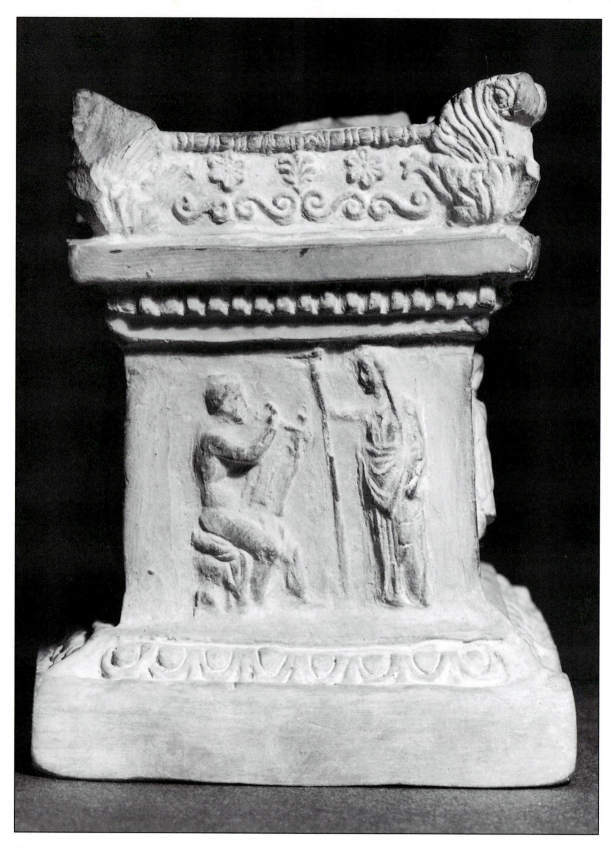

50

**58–61 Miniature Altar,** third–second century B.C.

The altar stands on a plain rectangular plinth, decorated at its top with an egg and dart moulding. All four sides are decorated with reliefs showing different subjects: a young girl, possibly a Nike, crowns a trophy; Poseidon, trident in hand, rests his hand on the shoulder of Amymone, who holds a hydria; Leto in the presence of her son Apollo Kytharoidos; and a Maenad kisses a Dionysos supported by a satyr. These panels are surmounted with a *taenia* which runs all round the altar, with a frieze of dentils above. This is crowned by a plain border, which forms a base for yet another border, adorned with various motives: spirals, rosettes alternating with palmettes, at the corners volutes of acanthus leaves joined by a bead and reel moulding. This last decorative element may have been inspired from some Egyptian bronze altars. The iconography of these panels is also popular on Megarian bowls most of which originated from Attica, and this led scholars to believe that the origin of the scenes should be sought in that direction and not in Magna Graecia as Wuilleumier was led to think. This thesis has now been confirmed by excavations in the Athenian Agora and other places where Attic influence and commerce were flourishing. Such miniature altars were apparently used as incense burners in household shrines, but it is not clear why they should have rapidly become popular all over the Greek world.

Oldfield collection 51. H. 9.7 cm. Clay pale cream.

Unpublished. Similar example from the Agora: D. B. Thompson, *Hesperia*, xxxi (1962) 258–262, pl. 91.

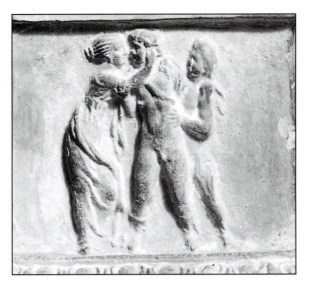

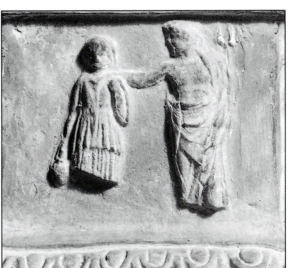

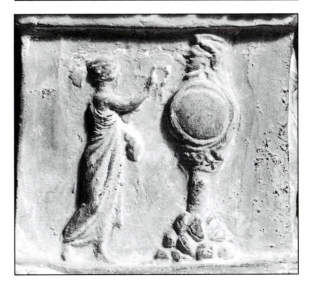

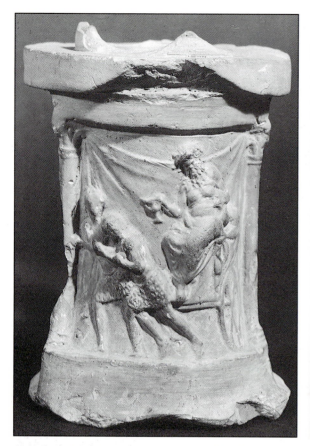

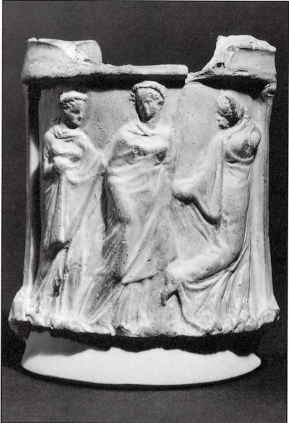

**62 Circular altar,** from Smyrna, end of the second century B.C.

A circular altar standing on a convex base with two round pillars supporting what appears to be an Aeolic-looking capital, and which together frame the scene. Between the pillars and secured behind them a drapery hangs loosely, forming a back-drop against which a Dionysiac procession is in progress, a device which is reminiscent of the reliefs supposedly depicting the visit of Dionysos to Icarius. A rather aged, fat and drunken Dionysos, with a *himation* draped round his hips, holding a kantharos in his extended right hand, sits on a chariot (in three-quarter view), pulled by two male figures. Dionysos with his head tilting forwards is shown bearded and possibly wearing a crown. His features are rather small and very worn. The two male figures pulling the chariot are also very worn and difficult to identify with any certainty. However, they appear to be wearing short speckled kilts which may suggest – as we know from vase-painting – satyrs, or barbarians.

1911.353. H. 14.3 cm. Clay orange.

Unpublished. Icarius reliefs: M. Bieber, *The Sculpture of the Hellenistic Age* (New York, 1961). figs, 656–657.

**63 Circular altar,** from Smyrna, end of the second century B.C.

Circular altar standing on a modern base, with a scene in relief confined between two pilasters. Three dancing girls, possibly representing either the nymphs or the Horai, are depicted clad in long *chitons* and muffled in their *himatia*. This motif of girls dancing in a row holding hands goes back to the Archaic period of votive reliefs and continues to the fourth and third centuries B.C., and became popular once more in Neo-Attic workshops. The girls' features are rather rubbed and therefore difficult to discern in detail. Their hair is treated in crinkly waves, pulled at the back into a bun chignon. A stippled crown is worn by all three. Their style of drapery recalls some types of Myrina figurines.

1910.720. H. 12.1 cm. Clay orange.

Unpublished. Votive reliefs: U. Hausmann, *Griechische Weihreliefs* (Berlin, 1960) fig. 1. Myrina figurines: *Louvre* ii pl. 112e; pl. 129d.

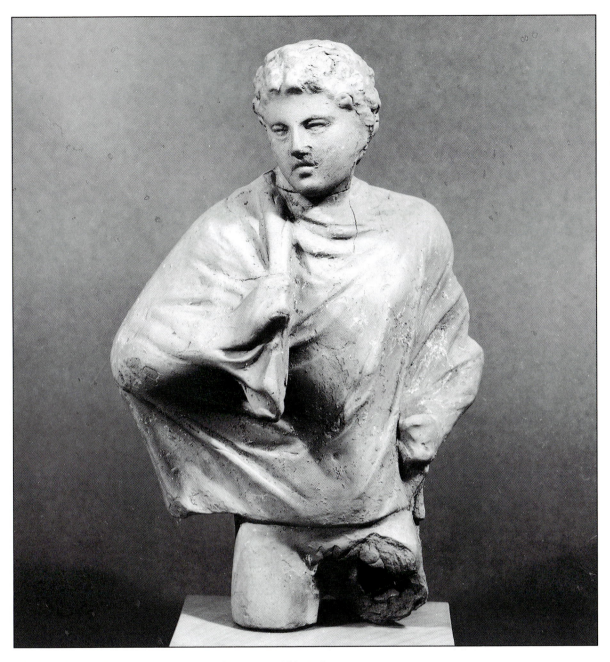

**64  Youth wearing a chlamys,** from Smyrna, *c.* 100 B.C.

The youth is draped in a short *chlamys* which covers both his shoulders and arms, and hangs in a straight line above his groin. One edge of the drapery is thrown over the right shoulder and falls in a deep fold down the front, being held by his right flexed arm. The left arm rests on the hip beneath the folds. The treatment of the drapery is very careful and in places it almost appears to be transparent; for example, the artist has allowed the navel to be seen underneath it, and also the outline of the right hand is well modelled. The crisp treatment of the folds, particularly round the elbows and forearm, and the manner in which the hanging folds are treated, are very reminiscent of the way in which the drapery hangs on the boy from Tralles. The head of our figure is slightly tilted to the right and the hair is shown in short curly locks. The face is chubby and youthful with a straight nose, full mouth with parted lips, and a distant expression underneath the heavy lidded eyes.

1911.40. H. 25 cm. Clay orange. Back modelled carefully.

Unpublished. The boy from Tralles: M. Robertson, *A History of Greek Art* (Cambridge, 1975) pl. 173*b*.

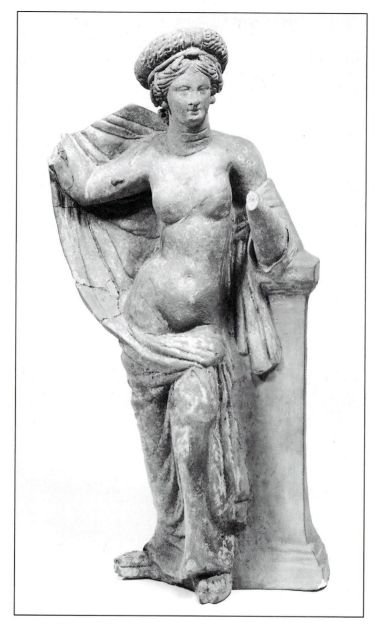

**65  Aphrodite,** from Smyrna, end of the second century B.C.

An Aphrodite stands on her right leg. The left is flexed and pushed forward. She is partially draped in her *himation*, her legs are covered, while above she is naked. Her right arm lifts the windswept drapery behind her back which forms a kind of niche against which the upper part of her body stands out. This motive appears also on reliefs and on other types of terracottas. It also appealed to mural painters. The other edge of the *himation* is draped round her left arm, which leans against a Doric pilaster. Her hair is parted and treated in fine strands on either side of the face, pulled at the back and tied in a knot. She wears a thick stippled crown and a fine diadem with tassels at regular intervals, also a pair of globular earrings. Her features are fine, but with the characteristic close-set eyes of the period, a straight nose, small mouth and round chin. On her neck the Venus rings are distinctly indicated. On her feet she wears thick-soled sandals. The type is very reminiscent of Aglaophon's Aphrodite. Therefore one may suggest that our example came from his workshop.

1911.23. H. 36 cm. Clay reddish with traces of white slip. Broken and mended, part of the drapery and right forearm.

Unpublished. For similar examples, see *e.g.: Louvre* ii pl. 31*b and d.*

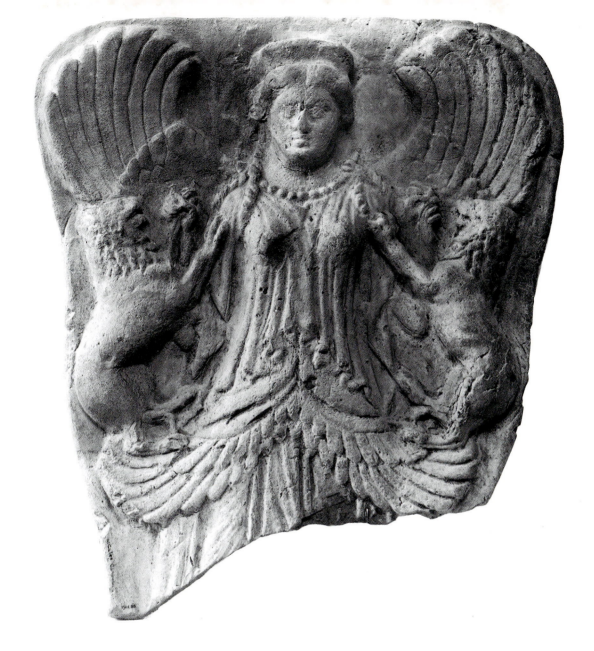

**66  The Mistress of the Beasts,** from Calvi, Campania, first century B.C.

Artemis is shown fully frontal wearing the *peplos*-form *chiton* with a deep overhang from beneath which a pair of spread wings seem to emerge, thus providing a base for the two lions which flank her. Another pair of wings rises behind her shoulders, and form a kind of shell against which her body stands. The folds of the drapery are indicated by narrow ridges with wide spaces between and scalloped out edges. A series of V-folds is formed between the breasts. What is visible of the lower part shows a heavy central fold hanging vertically. Her hair is parted and waved on either side of the face, and a pair of cork-screw tresses fall on either shoulder. On her head she wears a short *polos* and a necklace of beads round her neck. The lions, with their hind quarters resting on her central wings, have their left forepaw on her shoulder and the right one held in her upright hands. Their manes are treated in individual short locks, but their facial details are blurred, as are those of Artemis' face. Sadly, I have been unable to trace any parallels for this piece.

1911.88. Presented by C. L. Woolley. H. 38 cm. Clay reddish.

Lit.: *Report* 1911, 22., Fig. 10. Similar hair: A. H. Borbein, *Campanareliefs, typologische und stilkritische Untersuchungen* (Heidelberg, 1968) pl. 34, 2–3. Similar drapery: W. Fuchs, *Die Vorbilder der neuattischen Reliefs* (Berlin, 1959) pl. 10*c*.

# Glossary

*Apoptygma:* The bib-like material which folds from the shoulders to the hips.

*Arula:* Incense burner.

*Chiton:* A female dress made of linen with baggy sleeves. It was worn long by grown women and short by children.

*Chlamys:* An exclusively male short cloak worn both by warriors and by horsemen.

*Chous:* A small jug.

*Cista:* A box.

*Coroplast:* A maker of terracottas.

*Déhanchement:* The projection of the hip as a result of a relaxed pose where the weight is placed on one leg rather than two.

*Epiblema:* A small shawl-like over-garment for women.

*Hetaira:* A loose woman.

*Himation:* A rectangle of cloth worn as an over-garment by both men and women.

*Hydria:* Primarily a pot for fetching water. It had a handle at the back for pouring and two horizontal handles at the sides for lifting.

*Kantharos:* A drinking cup with high handles.

*Kekryphalos:* A headdress.

*Kolpos:* An overfall of material produced at the waist by a belt.

*Mitra:* A type of ribbon tied round the hair.

*Peplos:* A female dress generally made of wool and attached with buttons or pins at the shoulders. A belt was normally worn round the waist and a fold of cloth was drawn over it to form the kolpos.

*Polos:* A cylindrical headdress worn by certain goddesses.

*Protome:* Upper- and fore-part of a person or animal.

*Sakkos:* A Snood.

*Speira:* A mode of dressing the hair in a coil.

*Staphane:* A diadem.

*Taenia:* A flat band or ribbon worn round the hair.

*Venus rings:* Folds on female necks.

# Abbreviations

*AM:* *Mitteilungen des deutschen Archäologischen Instituts, Athenische Abteilung*

*ArchDelt:* *Archaiologikon Deltion*

*BABesch:* *Bulletin van de Vereeniging tot Bevordering der Kennis van de Antieke Beschaving*

*BCH:* *Bulletin de correspondance héllenique*

*BSA:* *Annual of the British School at Athens*

*BMCatalogue:* *Catalogue of the Terracottas in the Department of Greek and Roman Antiquities, British Museum* i (London, 1954)

*CVA:* *Corpus Vasorum Antiquorum*

Higgins, *Terracottas:* R. A. Higgins, *Greek Terracottas* (London, 1967)

*JdI:* *Jahrbuch des deutschen archäologischen Instituts*

*JHS:* *Journal of Hellenic Studies*

*Louvre:* S. Mollard-Besques, *Musée National du Louvre: Catalogue raisonné des figurines et reliefs en terre-cuite grecs, étrusques et romains* i-iii (Paris, 1954–72)

*Report:* *Ashmolean Museum, Annual Report of the Visitors*

Winter: F. Winter, *Die antiken Terrakotten* iii, *Die Typen der figürlichen Terrakotten* (Stuttgart/Berlin, 1903)